IMAGES
of America

DISCARD

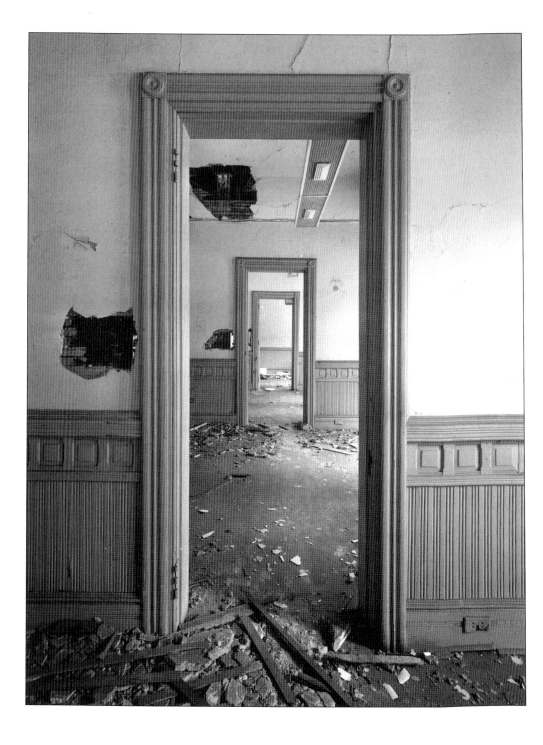

IMAGES
of America

PRINTERS ROW
CHICAGO

Ron Gordon and John Paulett

ARCADIA

First Printed 2003.
Reprinted 2004.

Published by Arcadia Publishing,
Charleston SC, Chicago IL, Portsmouth NH, San Francisco CA

Printed in Great Britain.

Library of Congress Catalog Card Number: 2003108120

For all general information contact Arcadia Publishing at:
Telephone 843-853-2070
Fax 843-853-0044
E-Mail sales@arcadiapublishing.com
For customer service and orders:
Toll-Free 1-888-313-2665

Visit us on the internet at http://www.arcadiapublishing.com

CONTENTS

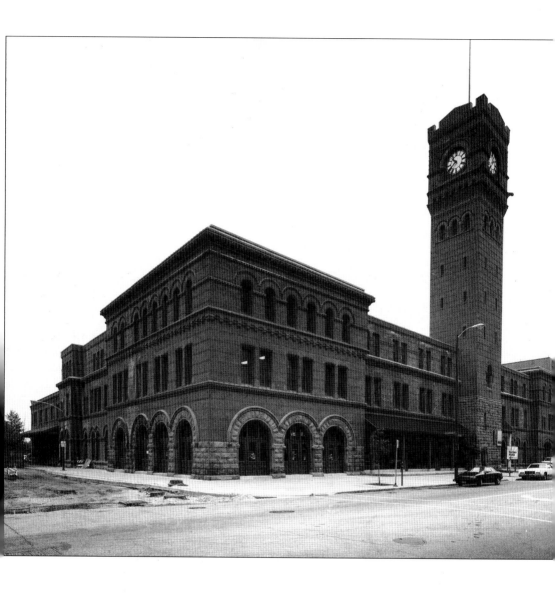

INTRODUCTION

AROUND 9:00 on a Sunday evening, October 8, 1871, somewhere near the O'Leary barn, the fire that would mark the beginning of the modern city of Chicago began. By midnight it had leapt over the South Branch of the Chicago River. Along the east side of the river, a collection of shacks and shanties called Conley's Patch surrendered to flames as the fire moved north. As thousands fled, the flames raced toward the north branch of the river and began to spread widely across the central business district. One part of the fire would move north as far as Fullerton while a second part wheeled around southward toward the collection of warehouses that made up the Levee District between what is now Harrison and Polk Streets. People watched in horror as it devoured the new and trendy Terrace House development on the current site of the Auditorium Theater. At that spot (today Congress Parkway), the fire stopped its southward progress just sparing the blocks that would become Printers Row.

Not that there was much of great interest to save. The area south of the Loop has always been dominated by commerce and, in the days before the fire, the river trade that stopped at the Custom House Levee on the south branch had created a rough and tumble area of warehouses and shanties. This wide-open atmosphere would last long after the fire as Chicago rebuilt. In the 20 years after the great conflagration, there grew up one of the most notorious vice districts in the nation in those same blocks. By the 1880s, Chicago had matured and become the rail center of the nation. Waves of immigrants, fortune seekers, and speculators poured into the city through the new Dearborn Street Station set in the middle of the Levee District at Polk and Dearborn. The purveyors of vice moved quickly into the old shanties to take advantage of "greenhorns" looking for adventure and naïve young women fresh to the city. A whole generation of famous madams such as Lizzie Davenport, Mary Hastings, and Carrie Watson employed an army of "cadets" to lure the unsuspecting into "a life of sin."

The red light district of Chicago became so notorious that, by the time of the Chicago World's Fair, books were published warning tourists to stay away from the Levee District. Some books went so far as to provide maps and names of the most notorious institutions. The unintended effect was that these warnings became guidebooks and were bought by out-of-towners eager for more dangerous entertainment after a day at the fair. The English reformer William Stead counted 37 houses of ill-fame, 46 saloons, 11 pawnbrokers, a shooting gallery, and too many gambling dens to list as he researched his book *If Christ Came to Chicago*. All of this was jammed into the few blocks between Harrison and Polk that we now know as Printers Row.

The city of Chicago tolerated the vice area as long as "decent folks" were not harassed and

the sin merchants stayed within the boundaries of the district. This "pact of toleration" was broken too often though and the district frequently overflowed into the theater and commercial areas for new recruits. In 1903, conditions had become intolerable and the mayor sent the resort keepers running for cover. The vice district did not disappear. It simply moved farther south to 22nd and Wabash. As the nightly entertainment vanished, the streets began to fill with commercial printing houses and bookbinderies. By 1910, the Levee District was no more. It had been replaced by Printers Row.

The printing industry had changed radically at the end of the 19th century. Until 1880, type had to be set slowly and by hand. The invention of the Linotype allowed quick setting of full lines of type and moved printing fully into the center of the American industrial revolution. The quick rise of consumerism and industry that followed the spread of the railroads radically increased demand for printed material. Farmers and small town dwellers now shopped through the catalogues of Montgomery Ward and Sears & Roebuck, both centered in Chicago. The printing presses of the Franklin Company, the Donohue Company, and others ran full time to meet the needs for books, catalogues, business forms, and advertisements.

The concentration of printing companies between Polk and Van Buren was a result of geography and transportation, two things that influenced much of Chicago's history. The same train station that had brought immigrants into the city now brought tons and tons of paper from the great mills. An underground rail system allowed paper to be moved down below street level at the Dearborn Station and then transported through tunnels directly to the binderies and print shops. The printers went to their basements and brought their materials directly in from the highly efficient rail system. In addition to access to raw materials, Printers Row was just blocks away from the explosion of skyscrapers in the Chicago business district. This kept the printers close to their customers in the most important commercial center in the nation.

Buildings on Printers Row were carefully designed to provide maximum floor space for printing operations. Large windows provided daylight to help the printers work accurately. The Printers Row area became a model for industrial efficiency, effectively using space, light, and the transportation network. We can imagine the streets full of the sounds and smells of ink and presses working full time to meet the printing needs of a growing nation.

The printers of the South Loop flourished throughout the first half of the 20th century. But by the 1960s, the industry was rapidly changing. Freeways and trucks brought paper more easily to dispersed manufacturing sites. Automation of printing required one-floor sprawling factories, located in outlying areas. The printing companies gradually began to abandon Printers Row leaving empty shells of buildings behind. To many Chicagoans, Printers Row had become an outdated eyesore. Most thought leveling the area in the name of urban renewal was the best choice.

In the late 1970s, a few Chicago real estate developers and architects recognized the potential for residential and commercial development of Printers Row. Once again, geography played a key role in the area's fortunes. Proximity to the Loop and transportation made the area desirable for people beginning to return to the center of the city. The large windows that gave extra light to printers during the early part of the century made for attractive lofts in the closing decades. The development began slowly. Often residents in newly created lofts lived in the same building as squatters who had found places to sleep for the night. Gradually the greasy spoons and vacant manufacturing locations gave way to art galleries, lofts, restaurants, and shops. Dearborn Station, once a main terminal for the Santa Fe Line, was converted into an urban mall. Because of the foresight of area developers, the architectural treasures of Printers Row were saved.

Today, Printers Row is one of the most vibrant communities in downtown Chicago. The old binderies are full of apartments and condominiums housing a diverse group of city dwellers. Students from nearby colleges fill the coffee houses chatting and working on term papers. On a summer evening, the many local restaurants and pubs open sidewalk cafes for community residents and visitors to the several premier hotels. In June, the Printers Row Book Fair attracts

over 75,000 people to almost 200 book exhibits. The growth of Dearborn Park and the South Loop area has encouraged the continued development of the historic area.

From its beginnings as a notorious vice district through the decades as a central part of the industrial development of Chicago to the current renaissance as a city living community, Printers Row has always surged with the vibrancy that is a signature of the proud city of Chicago. Visitors only have to walk through the charming fountain park in the center of the neighborhood to feel the special excitement and spirit that is Printers Row.

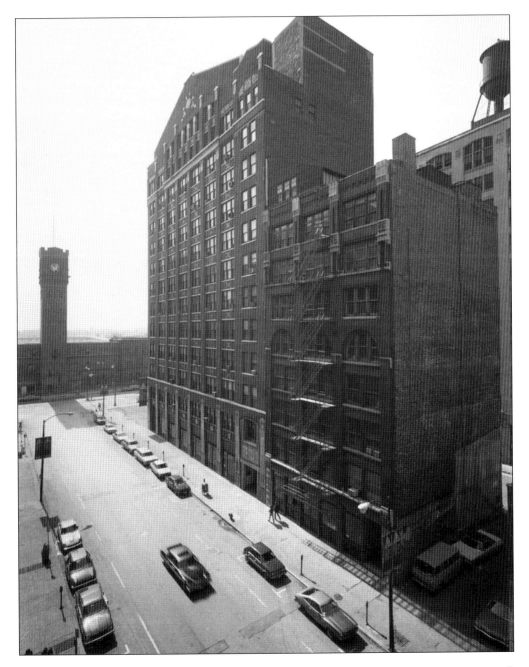

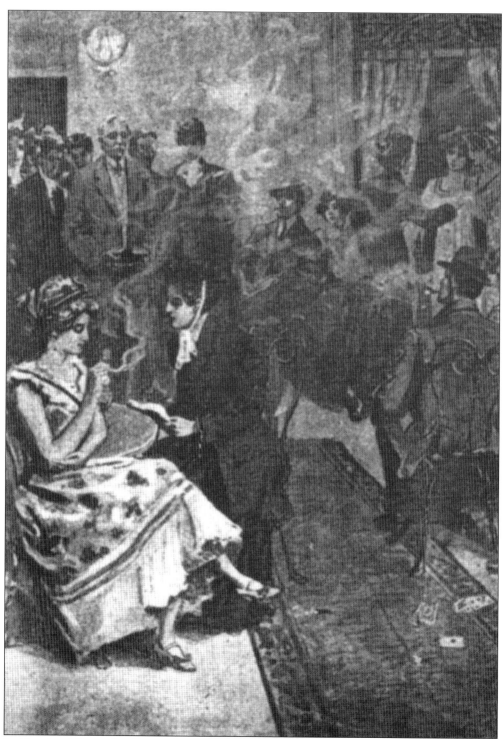

Inside a bordello in the Custom House Levee District, men and women engage in scandalous behavior including smoking cigarettes. The city fathers warned visitors to stay away from the area near Dearborn Station but their warnings often served only to increase the trade.

One

PROLOGUE

The Levee Vice District

BY THE TIME of the Civil War, commercial vice was common throughout the United States. In many places, prostitution was legal but never welcomed into polite society. It flourished in the corners and shanties of cities such as Chicago from the very first days. As immigrants flooded to the city in the 1850s, the infamous "patches" began to form along the Chicago river made up of vagrants, criminals, drug addicts, prostitutes, sailors, and the unemployed. The worst of these was run by an aging alcoholic named Mother Conley. Conley's Patch, as it was known, came to be the center of fierce anti-Irish hysteria. Originally located where the Wrigley and Tribune buildings stand today, the anti-Hibernian mayor Long John Wentworth used firemen and police to chase the squatters away. The vice district did not disappear though. It just moved down the river to the banks of the South Branch where River City Condominiums is now located

The *Chicago Tribune* described the Conley Patch as home to "the most beastly sensuality and the darkest crimes." From the shacks and shanties of the Patch grew an area extending east toward State Street between Harrison and Polk. Because the main street was Custom House Levee Road (now Federal Street), the center of saloons, gambling dens, cockfights, and dog races became known as the Levee District. Unable to eliminate vice, the city fathers were satisfied with keeping it quarantined in a red light district usually protected by the notoriously corrupt police force.

The Great Fire swept away the pox-ridden patches and left the Levee District unchallenged as the place for the more adventurous to seek nighttime entertainment. In the 1880s, immigrants and visitors poured into Chicago in ever greater numbers frequently arriving at Polk Street Station (now called Dearborn Station). To meet the growing demand for illicit activities, saloons and bordellos grew more and more lavish and complicated. Many had tunnels that allowed discreet escapes for well-heeled guests. Some of the madams of the bordellos were well known in society. Carrie Watson, who owned the most celebrated house of prostitution on Clark Street, was remembered as an extremely cultured woman of stunning beauty. At its peak, her brothel employed 60 women and enjoyed a worldwide reputation.

The best of the houses were on Clark Street. A block away, on today's Federal Street, were "panel houses." An unsuspecting rube might wander into one of these two story buildings where he would be drugged and strapped to the bed. An accomplice to the crime would slip through a hidden sliding wall and rob the poor fellow of everything including his clothes. The victims rarely reported the crime to the police. One policeman estimated that between 1892 and 1894, $150,000,000 was stolen annually in panel houses. On a busy night, $10,000 might be stolen on Federal Street.

Just north of the Levee District on Clark was once Chicago's original Chinatown, called

"Hophead Heaven" for its opium dens. The official policy toward all of the vice districts including the Levee District and the rougher Little Cheyenne and Hell's Half Acre, located just south of Harrison and west of Clark near the old Conley Patch, was one of toleration as long as the "decent element" was never harassed. As part of the First Ward, the Levee District was protected by the most powerful politicians in Chicago, Hinky Dink Kenna and Bathhouse John Coughlin. For fundraisers, Coughlin and Kenna would have the local madams supply prostitutes to the generous givers and patrons.

Outrage began to grow from the time of the World's Fair in 1893. One Chicago police officer declared that "there was no place in Chicago or in the whole country which would compare with (the Levee) in depravity." He described women at the doors and windows, frequently half clad, at all hours of the day and night luring visitors. Several buildings on Federal Street had extensions built out over the street so the women could exhibit themselves and sometimes seize the hats of men as they walked by.

After the Fair, the district began to shrink and, by 1903, reformers had sent the vice merchants scurrying to the emerging red light district at 22nd and Wabash. By 1910, the Levee District had disappeared completely. Custom House Levee Road was renamed Federal Street and the commercial printing and bindery buildings had replaced the two and three story brothels. None of these buildings remain today but a visitor can get a sense of what they might have looked like by visiting Halsted Street south of Maxwell, which was built at about the same time and has many similar structures.

Today, the street that once had the greatest density of "one dollar" shanties is occupied by the Borland Building, now the Printers Square Apartments. Lofts and offices fill the spaces on Clark that were once lavish bordellos. It takes a lot of imagination to walk through the quiet park of Printers Row and hear the echoes of the Levee District.

Opposite, top left: Magazine drawings depicted the pleasures and horrors of the Levee House Vice District. In the "Wild Nights" cartoon, a crap game is in progress. Although prostitution was initially legal, gambling was always outlawed. The upper right shows Clark Street with gentlemen mixing with women who tried to lure them into the better bordellos. The center illustrates the depravity of an all night saloon where women are seen smoking and drinking with men. On the far right, a "rube" is passed out and his pocket is being picked. "The Maze" on the bottom held a series of private areas where men could meet and select a woman for the evening. The postures of the two women at the table on the left suggest their low status and moral character.

Opposite, top right: A cutaway of Congress and State Streets reveals an elaborate panel house. There were bedrooms on the left and right on the second and third floors. The center is obscured by sliding panels where accomplices laid in wait to rob the unsuspecting patron. The exterior of this three-story building resembled those from the 1880s that are still found in many Chicago neighborhoods. The cartoon was a cautionary tale to young men who might wander into the Levee District that their goods and their dignity were not safe. The basement of this type of building often led to escape tunnels. A saloon or "maze" might have been on the first floor. Fancier brothels were found on Clark Street. This house was at the far east end of the district.

Opposite, bottom: This drawing depicts 130 Custom House Place. The escape tunnel was located where Printers Square Apartments (Borland Building) now stand.

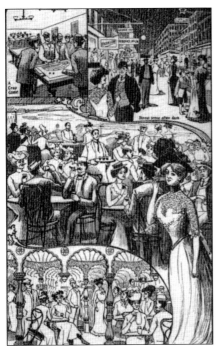

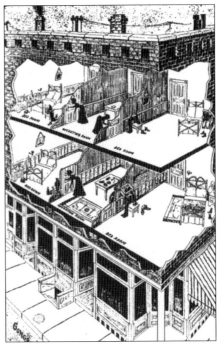

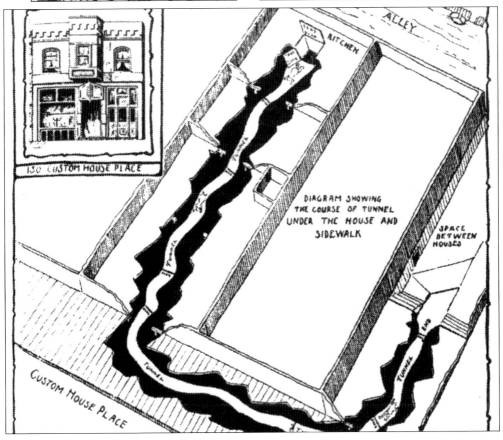

13

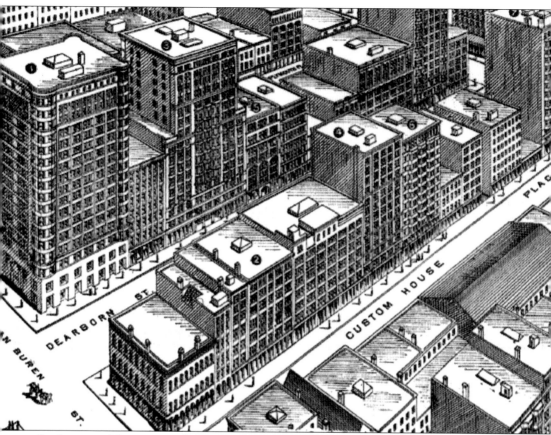

By the turn of the century, the shanties, shacks, and bordellos were disappearing quickly as the Loop expanded southward. Chicago was hemmed in by the river on two sides, the lake to the east, and the train yards to the south. Building upwards was the only solution and the growth of the skyscraper was the result. The area leading into the Levee District became prime property because of its proximity to both the business district and the train stations. In this bird's eye view, Federal Street is still called Custom House Place. The last of the vice area would be just beyond the upper right edge of the picture. Congress Parkway still ended at Clark. After the train station was removed, Congress was cut through to bisect Dearborn between Van Buren and Harrison. Number 1 is the Old Colony Building (1893). Number 2 is the Girard Building (1888), which was the first printing building. Number 3 is the Manhattan (1890), the first 16-story building. Number 4 is the Monon (1888) occupied by railroad and publishing companies. Number 5 is the Como Block (1888), which was the first of the better class of printing buildings. Number 6 is the Caxton Building, which housed engravers, printers, and publishers. Number 7 is the Pontiac Building (1890) and number 8 is the Ellsworth Building (1892). Both housed a wide variety of printers and publishers. After 1893, the printers would push farther and father south across Harrison and down to Polk.

Two

STONE AND STEEL

The Architecture

"LIMITED AS to the ground, business sought the air" wrote an early observer of skyscraper construction. Chicago was not an easy place to build high structures. The bedrock sat 90 to 150 feet below the surface and had to be reached through water and caving soil. The sand and soft clay would not support the foundation piles required for tall buildings with multiple basements that were common in New York. Architect John Root solved the problem by constructing a thin layer of cement which was placed on crisscrossed steel rails. This innovation allowed buildings to pass the theoretical limit of 12 stories and rise into the sky. Real estate developers and speculators built more and more elaborate structures down Dearborn Street to attract a variety of businesses. Many of the companies to move onto this block were railroad agents, manufacturer's representatives, publishers, and printers. This concentration of engravers, binderies, and lithographers gave rise to a new name for the Levee District. It became known as Printing House Row.

The location and street layout of the area south of Van Buren played a pivotal role in the building boom. The southern boundary (Polk Street) had Dearborn Station. Raw materials could be shipped in for the growing printing industry. An intricate system of rail tunnels was built below the street which allowed paper and other materials to be loaded off of trains and lowered onto subterranean rail cars. They would then move unseen at street level directly to the basements of the printers and binderies. Elevators were used to bring the materials up to the many printing houses.

On the north, the clients of the printers were in easy walking distance so new orders and work in progress could be moved quickly from customer to printer and back again. The narrow blocks of the Levee District (often half as wide as the rest of the Chicago grid) provided light on all sides of the buildings that usually occupied the entire block. Light and available materials combined with the proximity of clients to make the area ideal for development.

All of the most important architects of turn of the century Chicago are represented in Printers Row. The first buildings were developed by speculators who would rent space to a variety of printing and publishing tenants. Later buildings such as the Donohue Building were built specifically for one company. A walk down Printers Row is a history lesson in the development of the skyscraper. Buildings range from older stone wall supported structures such as LeBaron Jenneys' Rowe Building to steel frame skyscrapers such as the Manhattan Building.

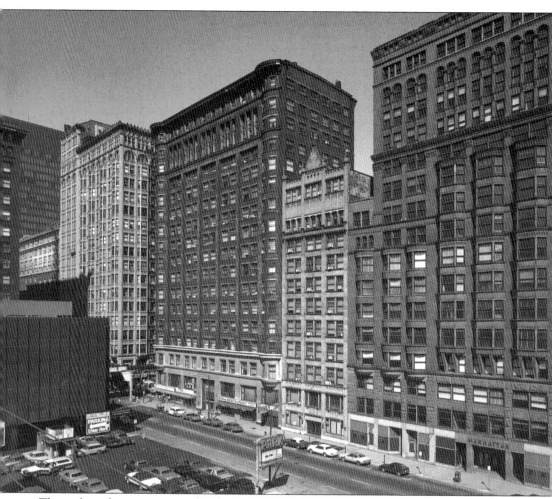

The earliest skyscrapers were developed to give homes to the growing printing and publishing industry. The Manhattan Building (far right, William LeBaron Jenney, 1891) easily filled offices with light through the distinctive bay windows. The Old Colony (center, Holabird and Roche, 1894) and the Fisher Building (Burnham and Co, 1896) pushed higher and higher to attract new tenants.

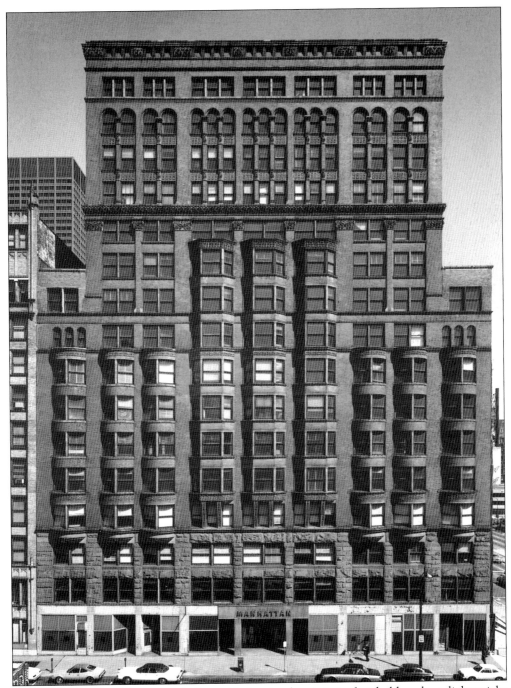

The Manhattan Building overwhelms with its size, but it is in fact held up by a lightweight metal frame. The skeleton is rivet bolted and wind braced. It represents a giant leap in skyscraper architecture. Stone facing on the first three floors gives way to brick with soaring vertical columns of bay windows.

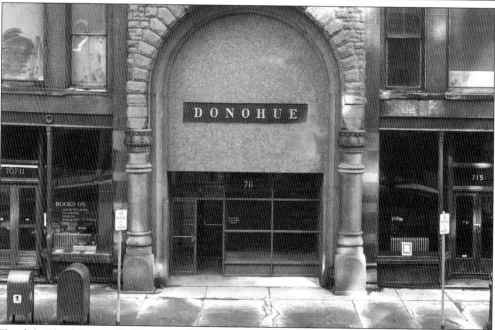

Top left: The Morton Building was built by Jenny and Mundie in 1896 for the Morton Salt Company. It was joined to the Duplicator Building in 1987 to form what is now the Hyatt on Printers Row.

Top right: Ottmar Mergenthaler invented the Linotype machine in 1884. By 1886, the company was operating in Printers Row in the Merganthaler Building.

Bottom: The Donohue Building (1893) was a different business model. Where the Manhattan and Fisher rented to a variety of printers and other businesses, the Donohue was built by a children's book manufacturer and used completely for its operations.

Top left: The Rowe Building is believed to have been designed by the "father of the skyscraper" William LeBaron Jenney. Notice the distinctive row of arched windows on the fifth floor and the two columned floors at the top. Early tall buildings often appeared to be several structures set on top of each other. Contrast this with the monolithic Monadnock Building.

Top right: The Pontiac Building (Holabird and Roche, 1891) sits between the Transportation and Morton Buildings on Dearborn Street. It was occupied by printers and manufacturers representatives.

Bottom left: The Pontiac is one of the four oldest remaining skyscrapers in Chicago and the oldest by Holabird and Roche. The brick curtain and bay windows cover the structural frame but do not reveal its lines, making it an unusual example of early skyscraper design.

Top right: Historically significant steel windows were added to the Mergenthaler Building in 1917. Providing light for the printers was a key feature of Printers Row architecture.

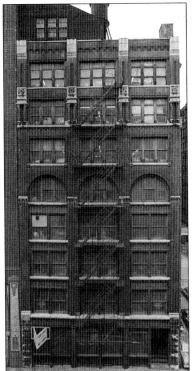

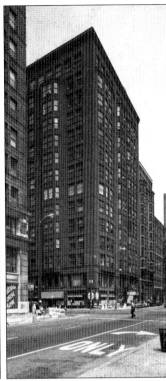

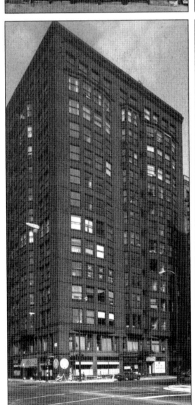

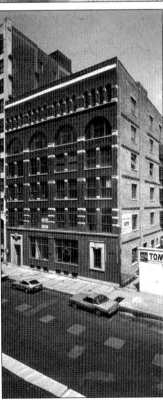

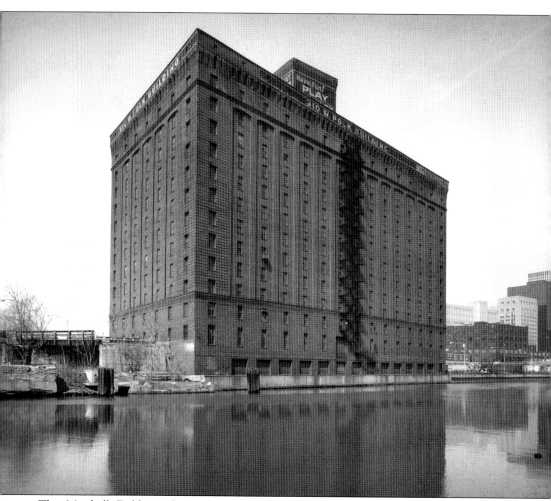

The Marshall Field warehouse (now demolished) was an excellent example of the severe functionality of Chicago architecture. Buildings were created to make money. In order to do that, the architect had to offer maximum internal space. Ornament was not as important as floor space.

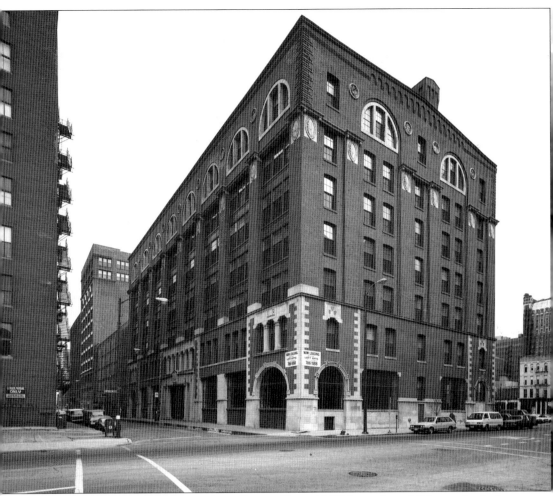

The Lakeside Press Building (Howard van Doren, Shaw; 1897) housed a publisher and printing facility. Lakeside Press produced a variety of popular directories that were the "yellow pages" of the late 19th century.

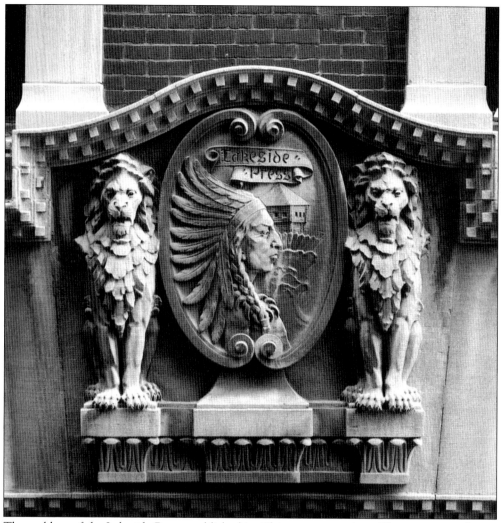

The emblem of the Lakeside Press established its Chicago connections. The company is better known today as R. R. Donnelly, one of the leading printers in the world.

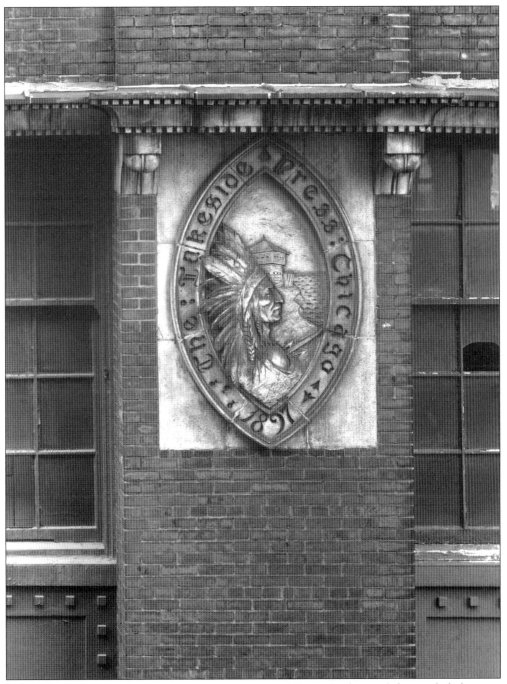

Lakeside was built in 1897. Although the exterior follows the lines of the steel skeleton, a considerable amount of ornamentation was used to support the important Lakeside Press brand.

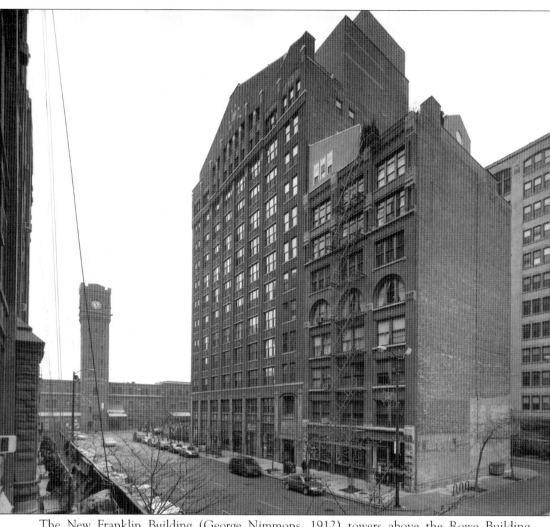

The New Franklin Building (George Nimmons, 1912) towers above the Rowe Building. Nimmons had built an earlier Franklin Building at 525 South Dearborn.

The Terminal Building held rail and custom offices. The stone on the first three floors and outer bay windows make it look like a smaller version of the Manhattan Building.

The Borland Building (Charles Frost, 1913) occupies the entire block from Polk to Harrison with four towers of descending height. The cascading elevations were designed to allow maximum light and prevent the creation of a "dark canyon" behind the Transportation Building.

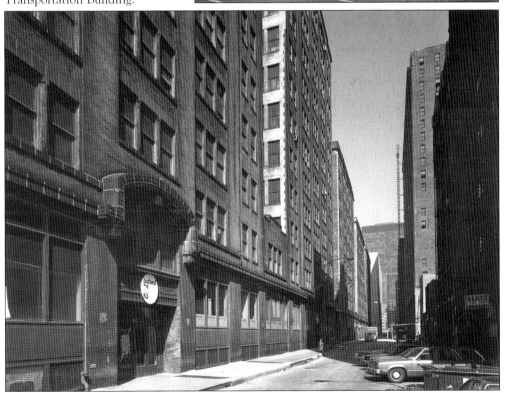

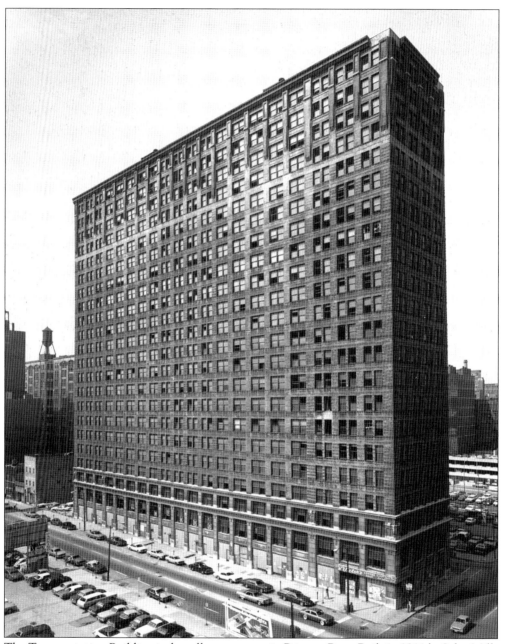

The Transportation Building is the tallest structure in Printers Row. Built in 1911 by John Mills van Osdel, it housed a wide variety of railway, shipping, and other commercial offices. Elliot Ness had his office on the third floor of the building during his gang busting days.

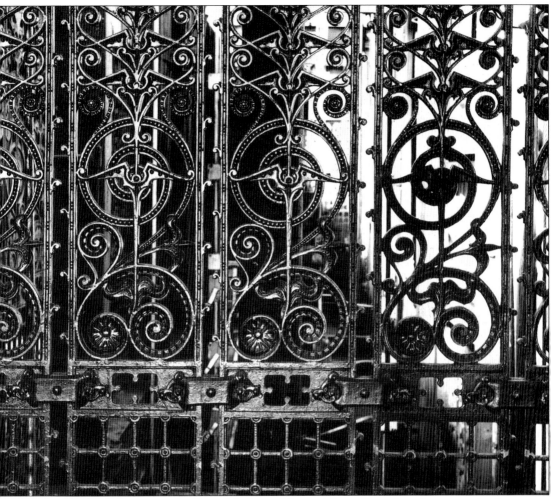

Improved technology in metals allowed light and beautiful scroll work such as seen in the interior of the Manhattan Building. At about the same time, Louis Sullivan was doing similar exterior work to the landmark Carson Pirie Scott Building.

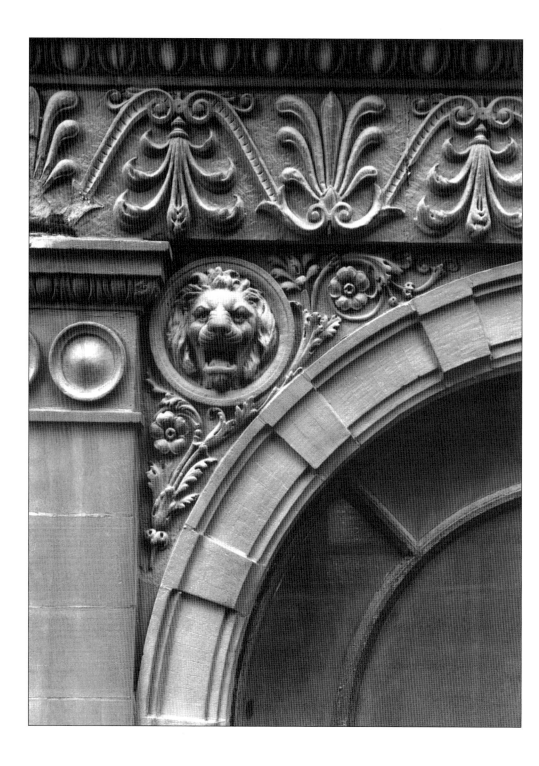

Three
RAIL CAPITOL
Dearborn Station

FROM THE BEGINNING, Dearborn Station dominated the area of Printers Row. Built in 1883 by architect C.L.W. Eidlitz, it is one of the best remaining examples of Romanesque train terminals. The station was functioning fully by 1885 and was a primary entry to Chicago for streams of immigrants throughout the end of the century. It was also the arrival point for millions who attended the 1893 Columbian Exposition.

The most important tenant of the station was the Santa Fe Railroad which operated the line from Chicago to Los Angeles. Legendary trains such as *El Capitan* and the *Super Chief* were favorites of Hollywood celebrities. The arrival of film actors to Chicago made Dearborn Station a favorite place for star gazing. From the 1920s to the 1940s, it was an almost daily occasion to spot the likes of Clark Gable, Carol Lombard, Bob Hope, and others coming into the station.

The station played an important role for less luminary Chicagoans as well as a gateway to the West. Americans began to vacation in the early years of the 20th century and Chicago families traveling to the Grand Canyon or other spectacular Western sites began their trips at Dearborn Station. Because it was the gateway to the romance of the emerging Western states, Dearborn Station held a special place for Chicago families.

Later stations such as Union Station were monuments to the triumph and wealth of the railroad industry. Dearborn had a blunt functionality that differed markedly from these great rail cathedrals. Viewing it today, we can sense an almost small town utilitarianism to the station building. Despite the smaller size of the lobby and interior spaces, the train yards were massive. They have been replaced now by the growing residential area of Dearborn Park.

The most dramatic feature of the station is the clock tower which, in a day of shorter buildings, could be seen from blocks away. The tower originally had a sloping roof that was destroyed by a fire. Otherwise it appears today much like it did in the 1800s. The tower still dominates the view as one looks south on Dearborn Street.

Inside the station were ticket counters, baggage service, and lounges. Fred Harvey had one of his legendary restaurants in the station building. At its peak, Chicago saw 1,000 trains a day steam in and out of the city. One observer reported that you could not see from Polk to Harrison because of all the smoke from the trains. Buildings such as the Borland were turned black from the coal burning engines. In addition to the Santa Fe, the station housed the Monon Line that ran to Indianapolis and Louisville; the Erie Railroad with service to New York; the Wabash to St. Louis; the Grand Trunk to Toronto; and the Chicago and Eastern Illinois to Alabama.

Besides its heavy passenger service, Dearborn was an important freight terminal serving the printers and publishers with paper and other materials. The intricate elevator and below ground tunnel system was incredibly efficient at moving materials to the many printing plants.

In 1922, a massive fire destroyed large parts of the station but it was promptly rebuilt in the same style (without the sloping roofs). By 1971, all passenger traffic had been rerouted to Union Station and Dearborn was abandoned. The train shed was demolished in 1976. Later all the rails would be removed to make way for residential development.

For a number of years, the station languished in disrepair. A concerted civic effort to renovate the structure has resulted in the creation of a small urban shopping area with restaurants, banks, shops, and a large medical practice. Dearborn Station remains the anchor of the Printers Row area today.

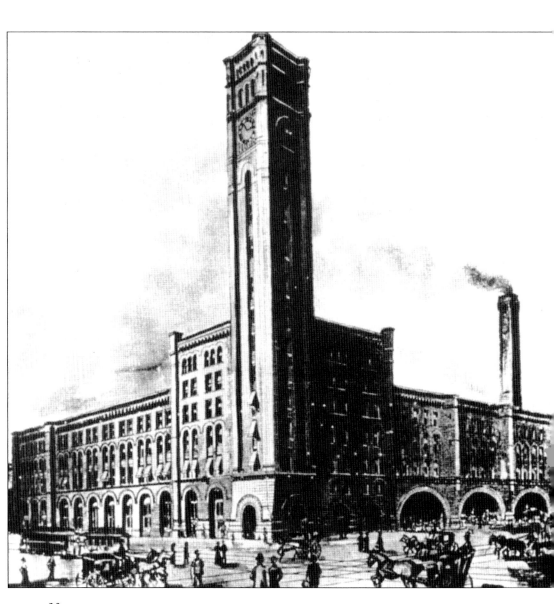

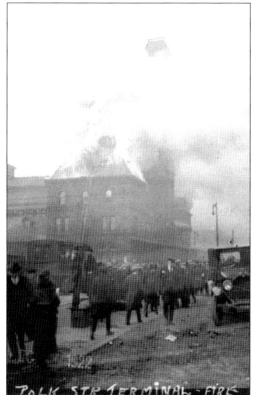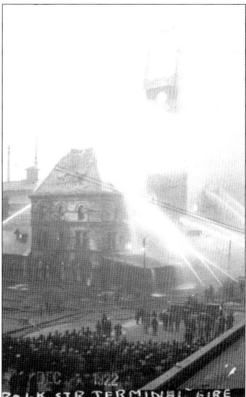

In 1922, a serious fire destroyed parts of what was then called the Polk Street Terminal. It was quickly rebuilt with only changes to the clock tower roof. The flames of the fire at the Polk Street Terminal could be seen throughout Chicago. Crowds gathered in the busy Printers Row area as smoke poured out of the building. The station was already a critical part of the Chicago transportation system especially for people traveling to or from Los Angeles. (Photos courtesy of the Library of Congress.)

Opposite: Grand Central Station sat next to Printers Row. The clock tower and Romanesque arches bore a strong resemblance to Dearborn Station. Unfortunately, this station was demolished, which makes the preservation of Dearborn Station all the more valuable.

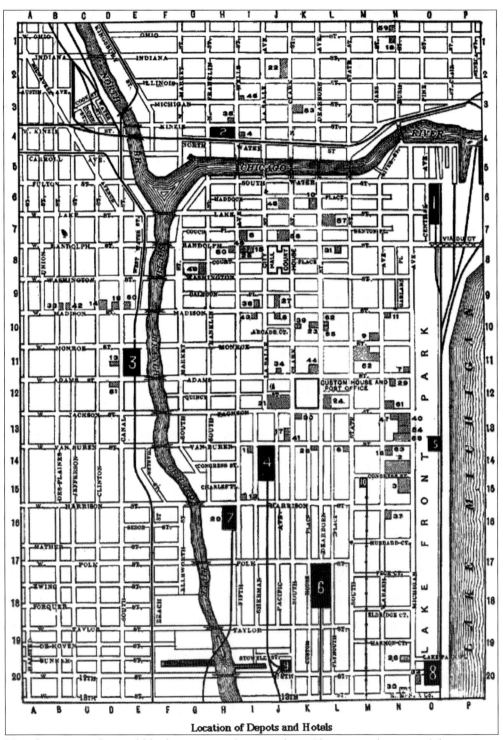

Location of Depots and Hotels

No other city in the world had as many rail terminals as Chicago at the turn of the century. Printers Row would form around Dearborn Station (number 6 on the map), which was the terminus for the key east-west routes. Geography would determine much of the area's future.

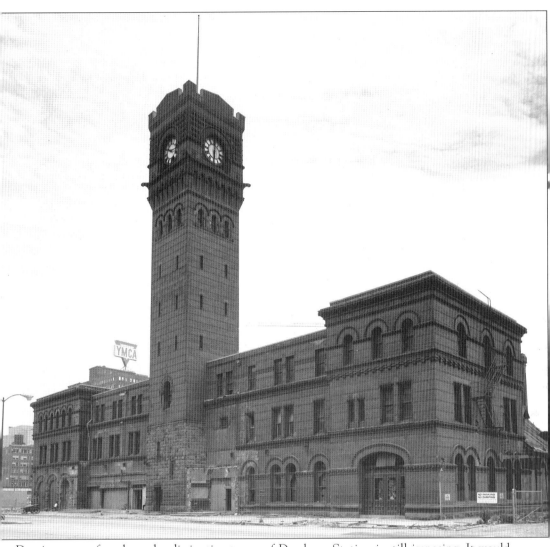

Despite years of neglect, the distinctive tower of Dearborn Station is still imposing. It would take tremendous imagination to see what the building could still become.

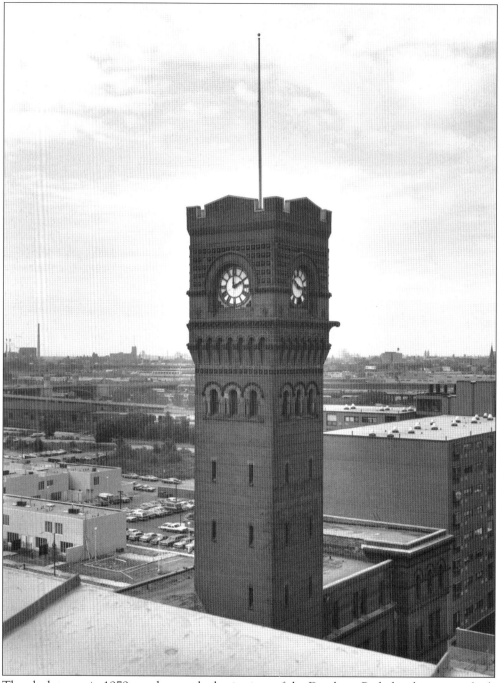

The clock tower in 1979 stands over the beginnings of the Dearborn Park development, which can be seen to the left. Dearborn Park was the first new development in the central city.

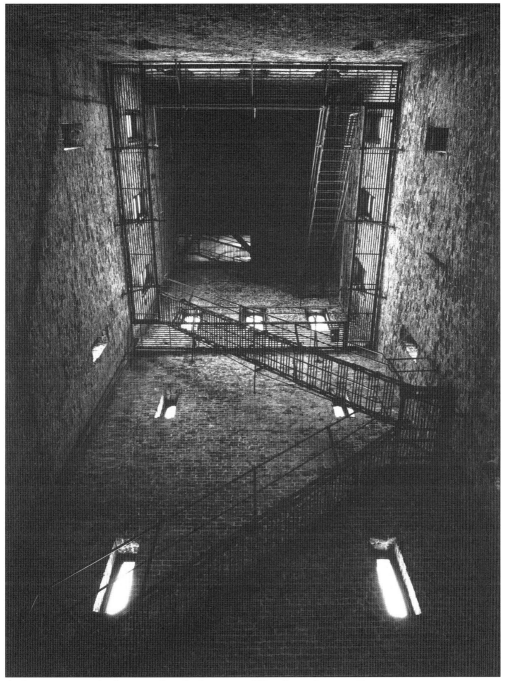

A dramatic view looking up the clock tower of Dearborn Station. Few visitors ever got to see this inner part of the station.

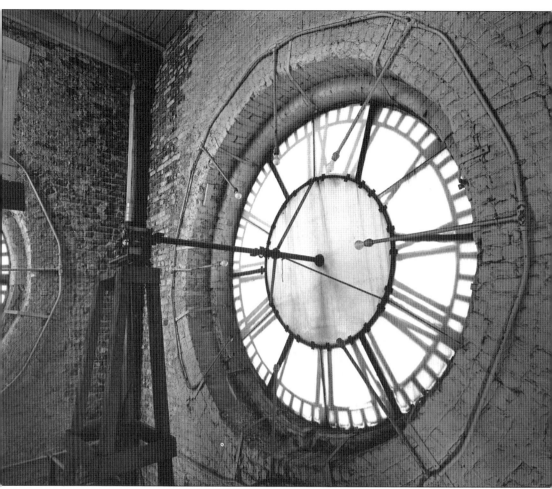

From inside the tower, part of the clockworks is revealed. Before skyscrapers filled the area, Chicagoans knew what time it was by looking at the Dearborn Station Clocktower.

In 1971, passenger traffic was rerouted to Union Station. The busy doorways of Dearborn Station were locked and the rooms were empty.

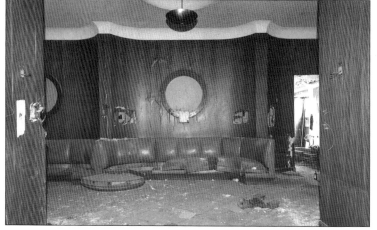

Top: The faded comfort of the lounge area can only suggest the glamour of Dearborn Station in the 1920s and 1930s. Virtually every Hollywood star who visited Chicago would have come through Dearborn Station.

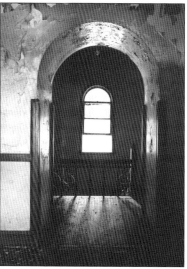

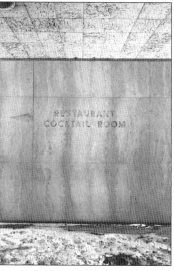

Middle Left: A walk inside the terminal after the traffic had stopped went though abandoned passageways with peeling paint. This opening went on to a balcony overlooking a small lobby.

Middle right: Dearborn Station did not lack amenities. For many years, it housed a Fred Harvey restaurant. The Harvey restaurants (with the famous "Harvey Girls") offered travelers consistent quality and service as they traveled.

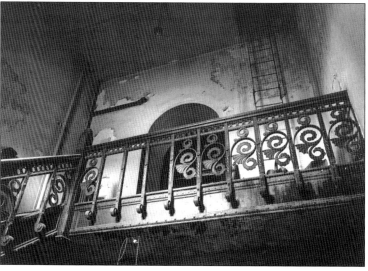

Bottom: Dearborn Station had a more functional small town feel than the monumental Union Station. The purpose of the station was to move passengers in and out of Chicago. Later stations were monuments to the wealth and power of the railroads.

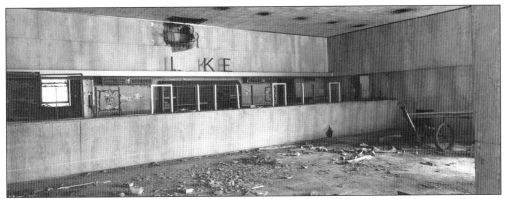

Above: At its peak, there were 1,000 trains coming in and out of Chicago every day. Dearborn Station was as important to the rail transportation system as O'Hare is to the air system today.

Right: Once busy gates and lobbies filled with snow as they were neglected in the decade after passenger traffic stopped at Dearborn Station.

Middle right: Air and automobile transportation decreased the importance of railroads and left the infrastructure, including baggage carts and old stations, to disintegrate.

Bottom right: Most of the old rail stations in Chicago including Grand Central and Van Buren were demolished. Dearborn Station once faced the same fate.

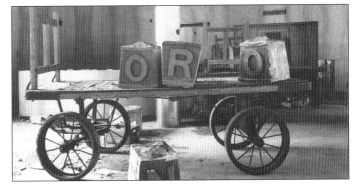

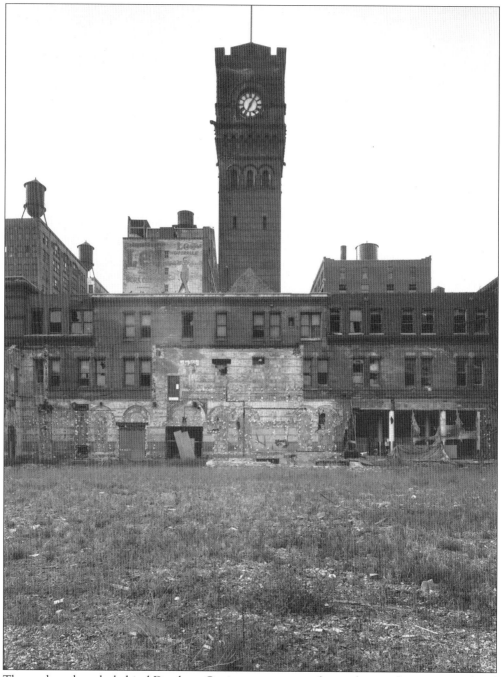

The yards and tracks behind Dearborn Station were removed to make way for commercial and residential development. Offices, shops, and restaurants would replace the deserted lobbies.

In 1979, the shed and rear section of the station were demolished. Innovative developers would add new parts to the building where the old tracks had been.

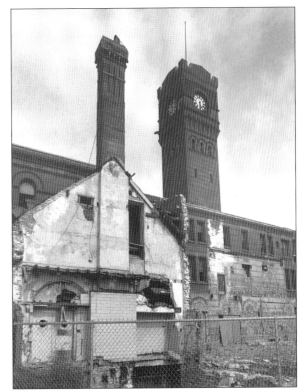

In this 1986 photo, the train yards are gone and modern structures blend with the historic Dearborn Station. A music school would later become among the varied tenants.

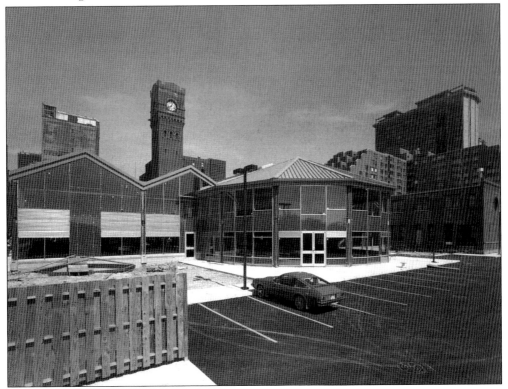

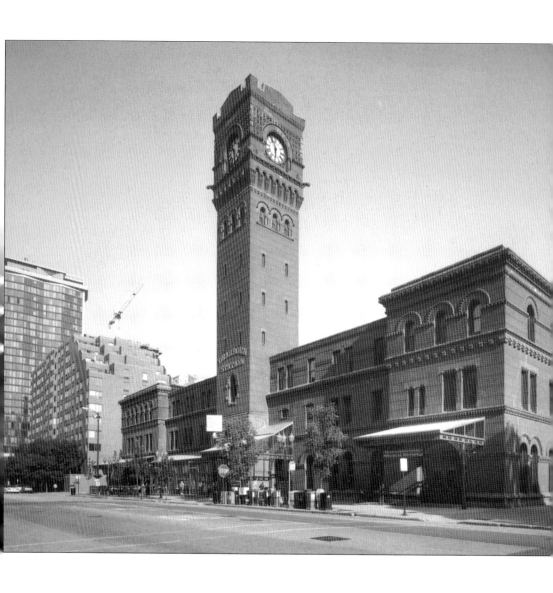

Four

INK AND PAPER

The Printing Industry

FOR OVER 400 YEARS following the invention of the moveable type printing press by Gutenberg in 1448, the process of setting type changed very little. Letters were selected from a distribution box and lined up on a composing stick until it was full. This slow process served the limited printing needs of four centuries but could barely keep pace with the burgeoning demand for printed material during the height of the industrial revolution. Just as the railroad and the telegraph accelerated transportation and communication in the 1800s, new technology changed the printing industry allowing fast, economical production of vast quantities of printed material for businesses and consumers.

The first practical mechanized typesetting machine was invented in 1884 by Ottmar Mergenthaler. Called a Linotype, the machine produced lines of text from rows of matrices using a keyboard similar to a typewriter. The Linotype was much faster than human-hand typesetting and required less staff and less skill to operate. The result was that, like many of the innovations of the Industrial Revolution, printing passed from being a highly skilled craft into a more automated industry which could produce mass product at low cost.

Within two years of his invention in Germany, Mergenthaler opened a facility in Printers Row. The Mergenthaler Linotype Building (now residential lofts) was built in 1886 and still stands on Plymouth Court. In many ways, it is the most important site in American printing history. Residents of the building still notice heavy beams and slanted floors that are the result of the heavy Linotype machines that thundered as lines of type were set and presses rolled.

The printing buildings of Printers Row fell into two groups. The earliest buildings were developed by groups of investors and rented to commercial firms. In buildings such as the Pontiac, a wide variety of smaller printing companies occupied space and served such needs as railroad timetables and business forms. With the growth of the Linotype process, large printing firms such as Lakeside Press and M.A. Donohue emerged. These growing concerns erected their own buildings and filled the space with machines that printed and bound material as diverse as children's books and racing forms. The structures they occupied needed extra support to hold the weight of the machinery and raw materials. The large windows allowed maximum light for detailed printing work. Residents of Printers Row today enjoy the benefit of this light in the well lit loft spaces.

By the 1970s, the printing industry had moved away from the center of the city. A few small job shops remain in Printers Row but the sound of roaring presses and the smell of ink has left the area forever.

Printing had not changed substantially in 400 years until the development of the Linotype. The growth of the consumer economy created a huge demand for catalogs and booklets. Montgomery Ward and Sears Catalogs brought consumer goods to the small towns throughout the West.

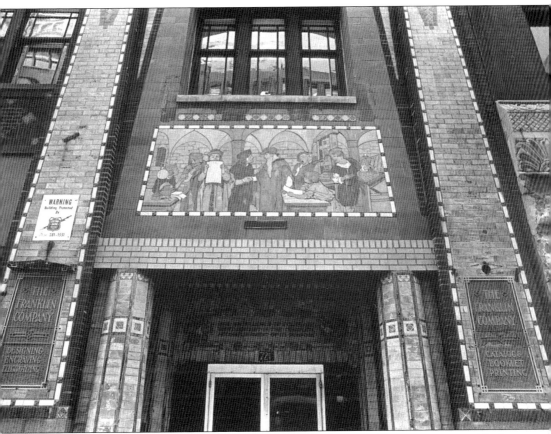

The terra-cotta face of the New Franklin Building told the history of printing starting with the Gutenberg Bible.

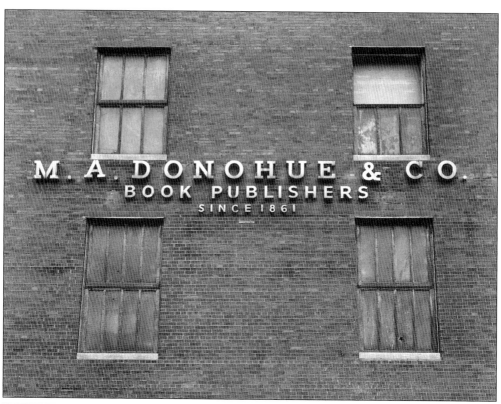

The M.A. Donohue Company was a major publisher of children's books, including the *Wizard of Oz*. L. Frank Baum modeled the city of Oz after Chicago. The name came from his filing cabinet which had the letters O-Z.

A sense of the history of Printers Row was maintained in the museum on the first floor of the Donohue Building.

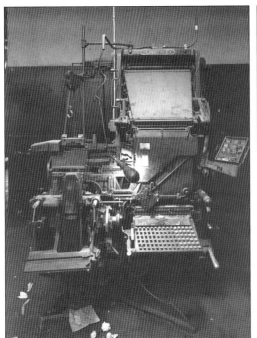

Presses from the printing company included the Linotype, which brought printing into the Industrial Revolution. Before the invention of the Linotype, each letter would be placed in a stick and lines of print were composed. Linotype made printing fast and economical.

The Lakeside Press would become R.R. Donnelly, the largest printer of the Yellow Pages. In later years, the Daily Racing Form was printed in the Lakeside Building.

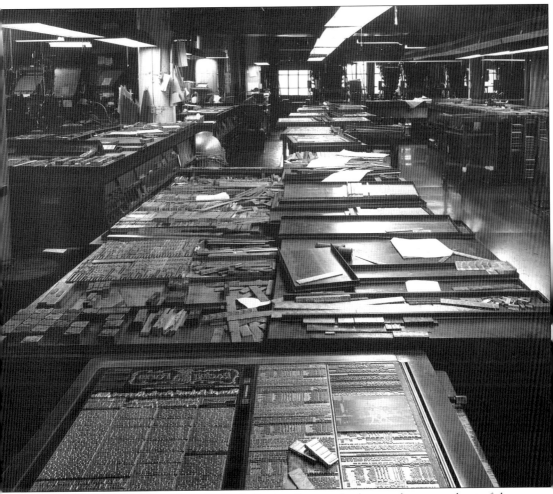

Day after day, publications such as the Daily Racing Form and other catalogs poured out of the buildings of Printers Row.

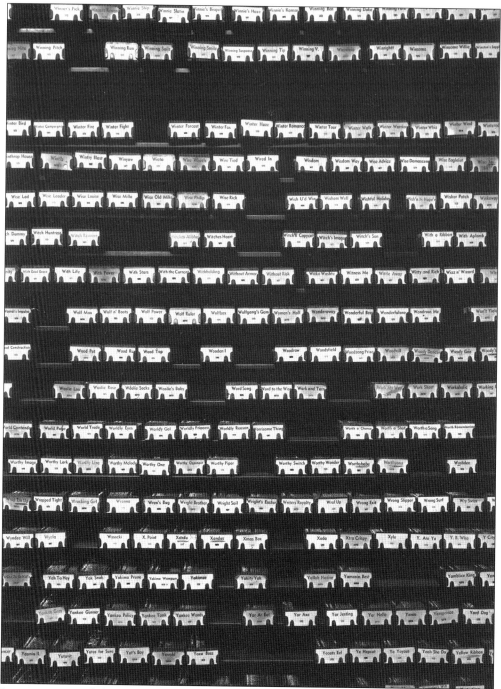

Just a portion of the "W-X-Y" section of plates from the Daily Racing Form shows the dimension of turning out publications every day for the popular horse racing tracks.

Opposite: Behind the buildings and presses of Printers Row were hundreds of hard working printers who applied their skills and experience to the success of the industry.

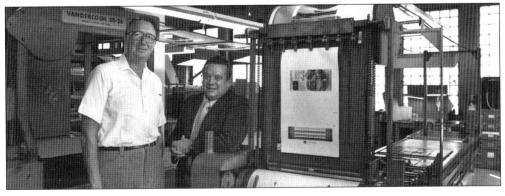

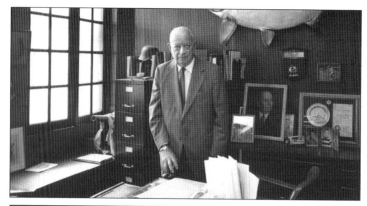

The story of Printers Row was the story of the Industrial Revolution in America. Owners such as Rudy Koenig, managers, accountants, pressmen, and office clerks all worked together in the busiest printing area of the nation.

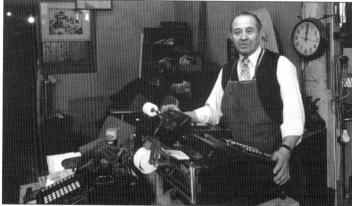

Milton Goldman supplied furniture to the industry.

Bottom left: Elevator operator Owen Conlin stands ready.

Bottom right: Herman Kramer was still working after all of the large printing companies were gone.

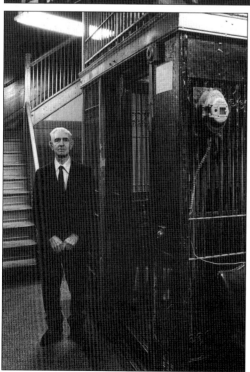

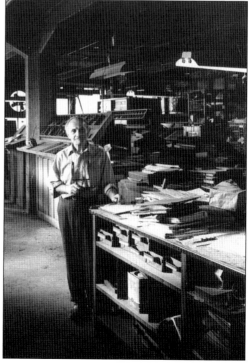

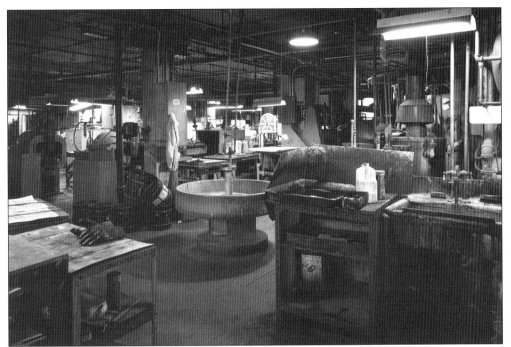

Changes in the economy and logistics made the buildings of Printers Row less and less attractive to printing companies that no longer needed to be physically close to their customers in the Loop.

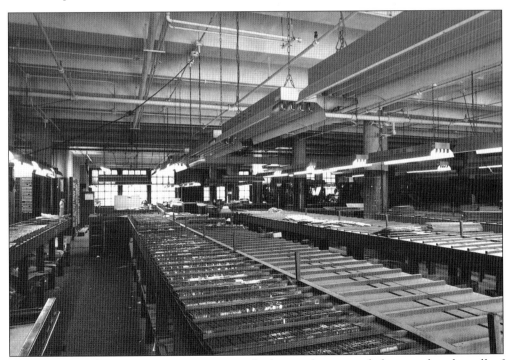

By the 1970s, the great printing companies had moved away and the sound and smell of printing was gone from the area forever.

Five

PEOPLE AND PLACES

Lost Neighborhood

DURING THE 1970s and 1980s, Printers Row disappeared from the consciousness of most Chicagoans. No longer the area for saloons and bordellos, nor the center of the printing industry, it became a largely forgotten district just south of the Loop. While few people from the suburbs or the center of the city ventured into the area, life did not disappear from the streets. A few printers still worked there and small taverns and grills served the employees.

In these decades, the area south of the Chicago Loop saw a general decline. At one time, the south side throbbed with life and vitality. South State Street had been a center for jazz and late night clubs featuring such performers as Louis Armstrong. Al Capone made his headquarters at hotels on South Michigan Avenue. But after the social changes of the 1960s, the center of Chicago moved. Residents were following the jobs to the suburbs and the business interests were moving farther north. The rail yards that had given vitality to the Printers Row area were abandoned as passenger service moved to Union Station.

The abandoned buildings of Printers Row became a haven for the homeless who gravitated toward the South Loop. Many of the underprivileged were served by the area's oldest resident, the Pacific Garden Mission. The mission was originally founded as a Sunday School on State Street in 1873. In 1880, the mission moved to a location on East Van Buren which had housed a notorious saloon called the Pacific Beer Garden. Dwight Moody, fresh from evangelistic meetings in England, suggested that the word "Beer" simply be dropped from the name and "Mission" added. It was a not so subtle message to drinkers that they should turn away from a life of sin and alcohol. Billy Sunday, a popular baseball player with the Chicago White Stockings, came to the mission in 1886 and, hearing the message from the wagon at State and Van Buren, was converted. He turned down a lucrative baseball contract and became a world famous evangelist.

In 1923, the Mission moved to its current location on South State Street on the east boundary of Printers Row. The move was to follow the shifting "hobo" population that now occupied the South Loop area called "Murderer's Row" because so many people had been killed there. Cheap flophouses along State Street often housed 5,000 men a night. From this site, the Mission launched *Unshackled*, the longest running radio drama series in history.

Homeless men spilled over from State Street into the blocks of Printers Row and, in some cases, became squatters in the abandoned printing buildings. This contributed to the continuing decline of the area as businesses moved away from what was becoming a "slum." Throughout the decades, a few businesses such as Blackie's Tavern endured, adapting to the changing demands of the community. The environmental sculpture of "Tom's Grill" on Harrison stands as a reminder of this period.

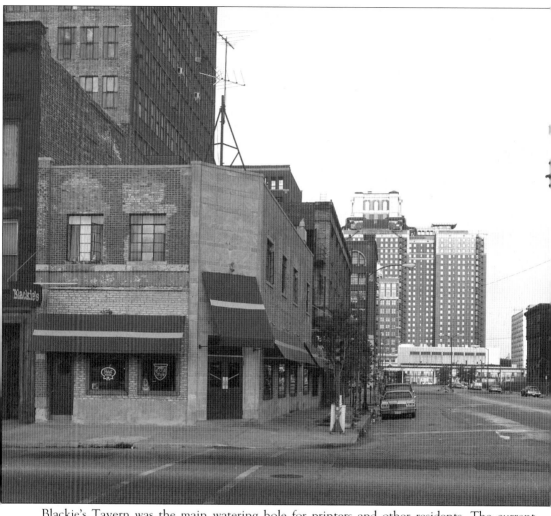

Blackie's Tavern was the main watering hole for printers and other residents. The current Hilton Hotel is visible at the center and Dearborn Station before the restoration is at the right.

Opposite: Once a "shot and a beer joint," Blackie's is now one of Printers Row's most delightful and historic restaurants. It is still owned and operated by the family of founder Alex DiMilio. You can still meet his daughter Doreen and colorful greeter Sam at the restaurant.

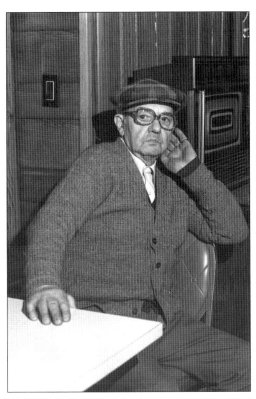

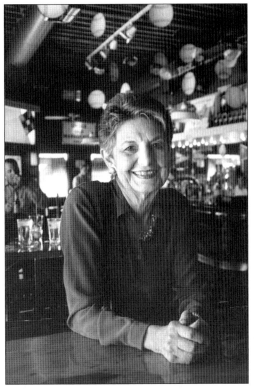

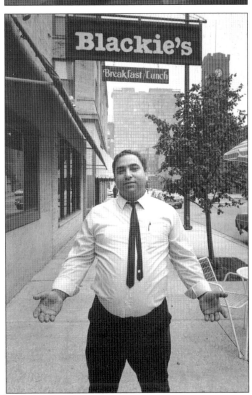

An evening at Blackie's.

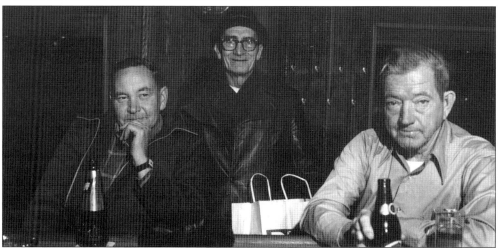

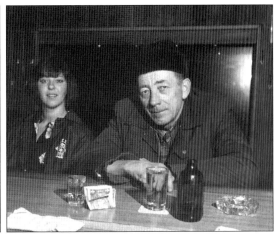

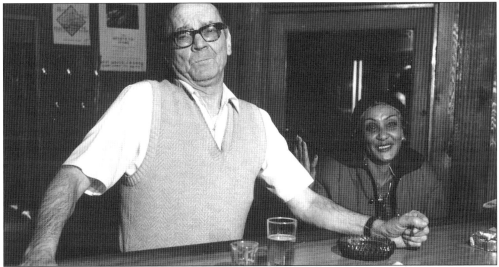

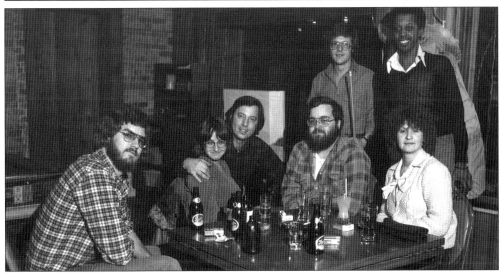

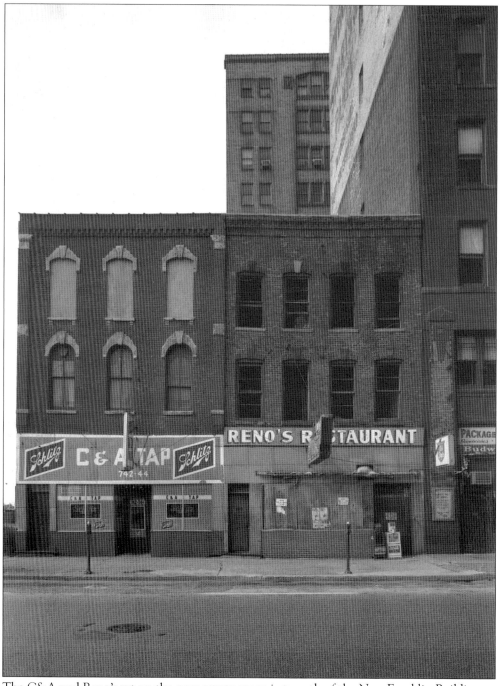

The C&A and Reno's sat on the now empty space just south of the New Franklin Building.

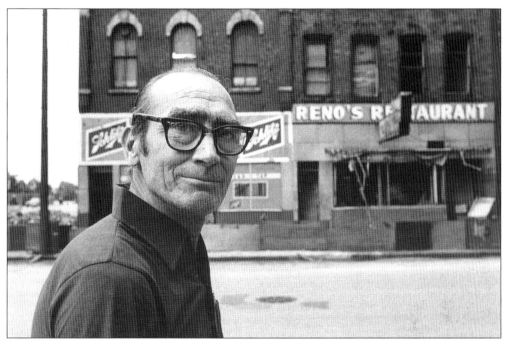

A resident might find his way to Blackie's, the C&A, and Kasey's Tavern all in one evening.

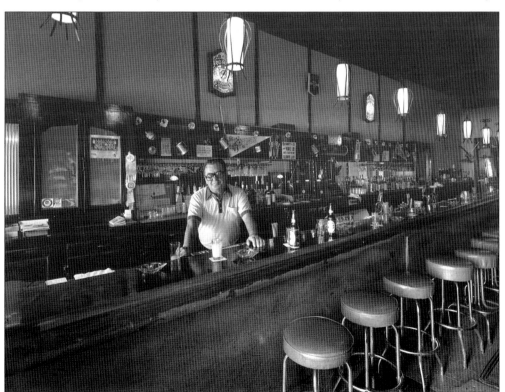

Kasey at his eponymous establishment. Crowds still fill Kasey's most nights of the week. It continues to feature sports banners even though the Chicago Sting is long gone.

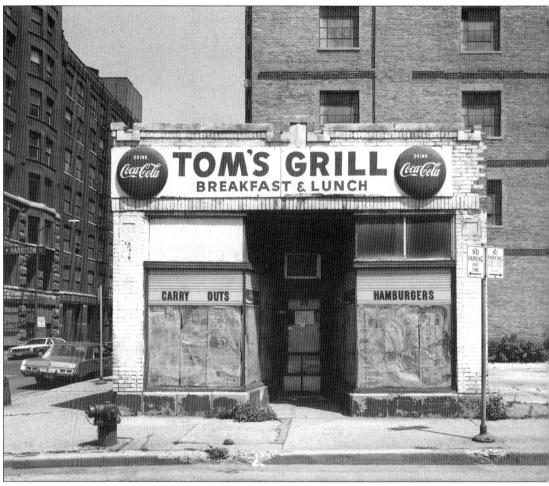

Tom's Grill at Harrison and Plymouth has been preserved as a part of the urban archeology. Visitors today will notice that the round Coca Cola signs were removed by vandals and replaced with square signs. The building frame provides a lasting reminder of another era.

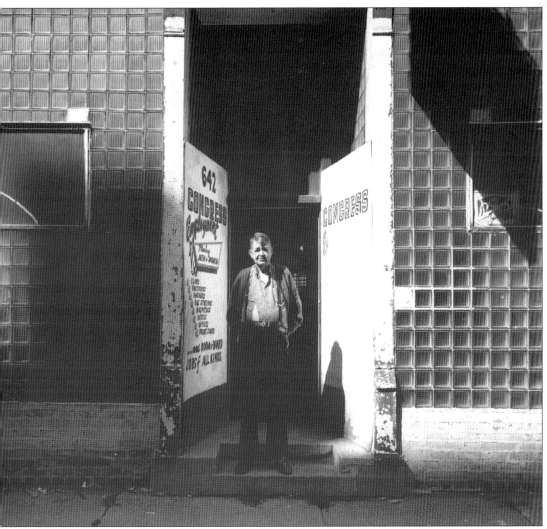

Congress Employment provided day laborers to a wide variety of companies long before the boom of temporary staffing. The building stood in the middle of Printers Square at the site of the current fountain square.

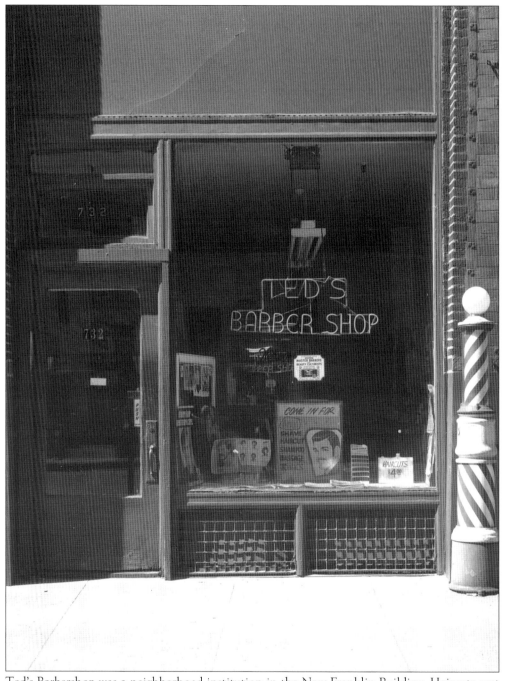

Ted's Barbershop was a neighborhood institution in the New Franklin Building. Haircuts cost only $4.

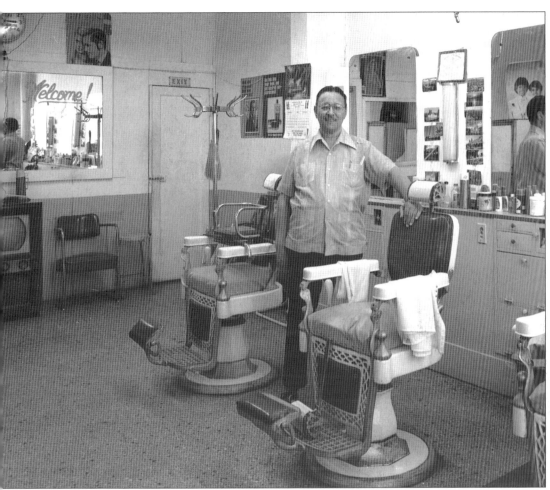

Ted was so unwilling to leave his shop that he was giving a haircut the day the first wrecking ball went through his wall. This picture from 1979 shows a television that was already long out of date along with an incongruous picture of Donny and Marie Osmond.

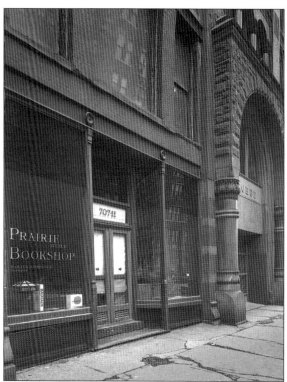

Early residents of the reviving commercial area of Printers Row included the Prairie Avenue Bookshop and Foley's Printers Row Restaurant, still one of the finest dining places in the area.

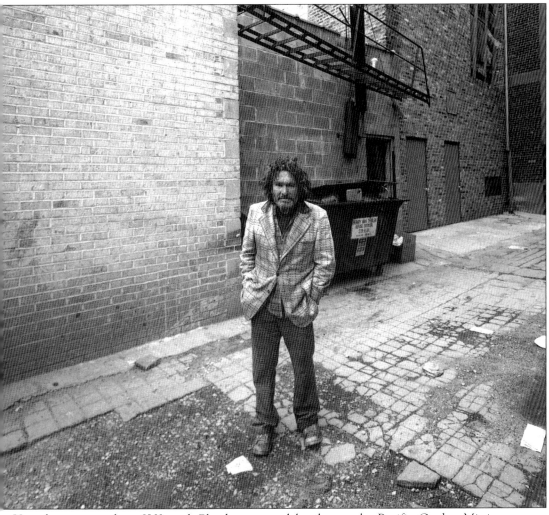

Homeless men such as K.Y. and Claude, attracted by the nearby Pacific Garden Mission, became familiar to the residents of the area.

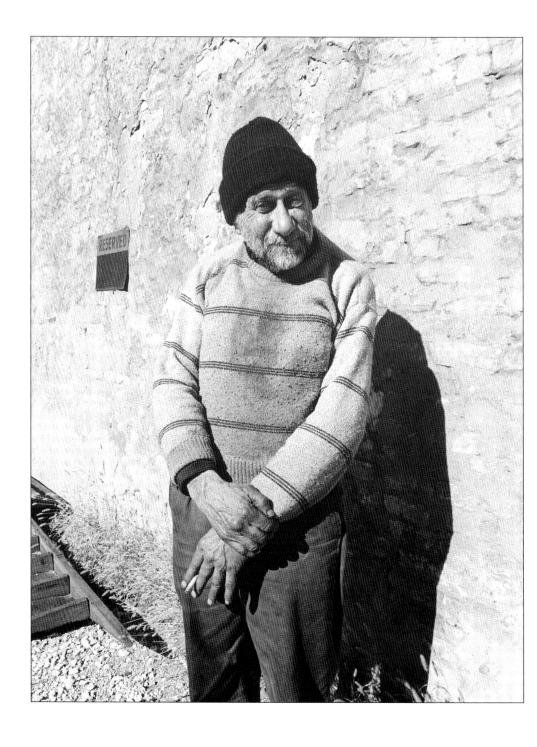

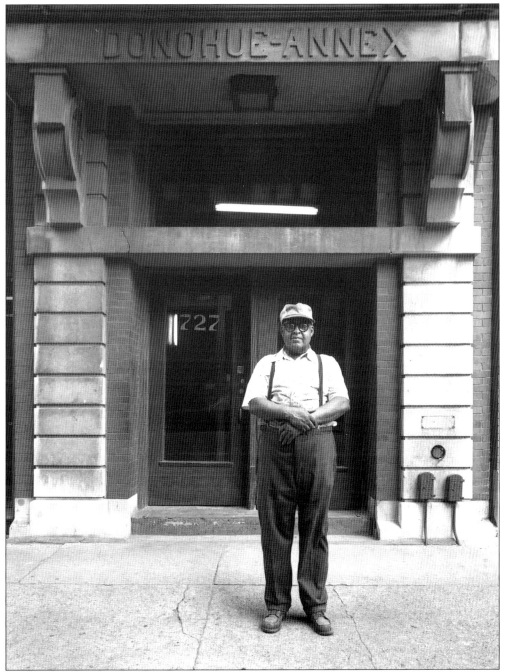

Mr. Julius was said to be the "brains" of the Donohue Building. He was known to all of the residents of the area as a gentleman who greeted every passerby.

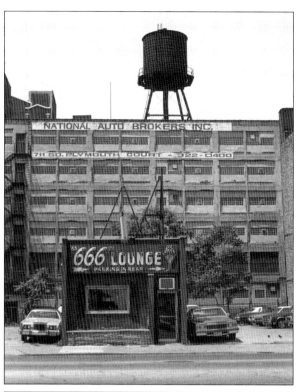

Two remnants of the infamous Whisky Row along South State stand just south of the Pacific Garden Mission.

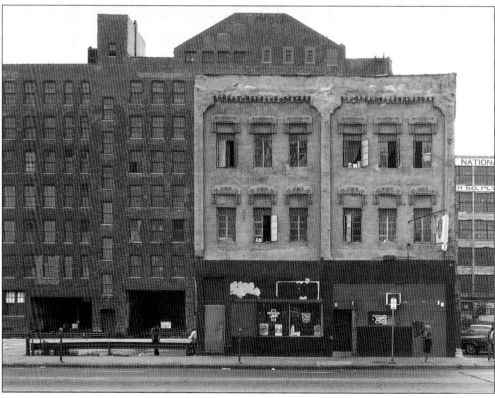

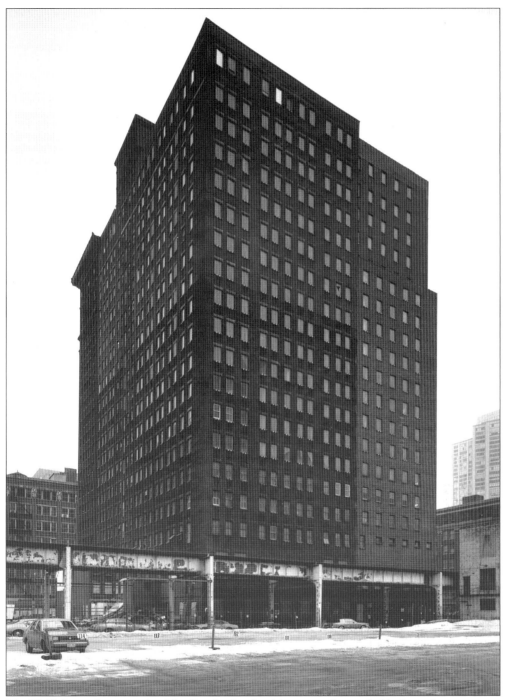

The YMCA stood just south of the Pacific Garden Mission and provided lodging for many men in the South State Street area.

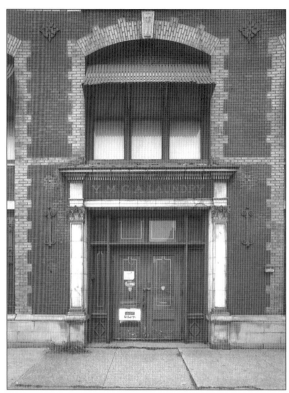

The distinctive YMCA Laundry Building is now gone. The two and a half story structure gives a good indication of what the street looked like earlier in the century.

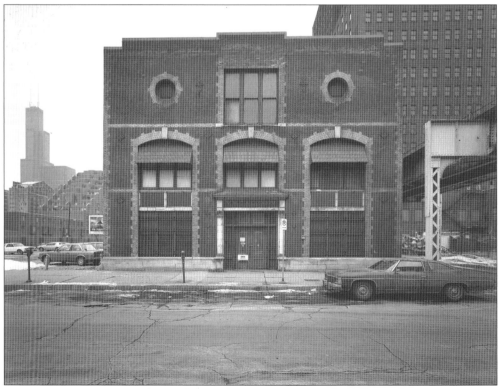

The interiors of buildings such as Transportation were left empty and became temporary shelters for the homeless. When reconstruction started, several dead bodies were removed from the building.

Six

ABANDONMENT AND DEMOLITION

Lost Buildings

IN THE 1960S, many city planners believed that urban decay could only be cured by tearing down slum areas and building new modern structures. This came to be known as "urban renewal." Faced with debilitated areas of abandoned buildings, civic leaders brought in the wrecking ball and bulldozers to clear away the slums and replace them with high rise buildings and more open spaces. The South Side of Chicago was a prime target for building demolition. The area just west of Halsted was cleared to make space for the University of Illinois-Chicago. Other neighborhoods were cleared or cut in half to build the expressways that would hasten the exodus of residents to the suburbs. Public housing apartments were built in place of the crowded streets east of the Dan Ryan Expressway.

Many important pieces of architecture were lost with the demolition of decayed neighborhoods. It is part of the "miracle" of Printers Row that most of the significant buildings in the area were spared the wrecking ball. A number of buildings including most of the train stations around the district were destroyed. Dearborn Station was spared. On Dearborn Street, several smaller buildings were torn down. In some cases, new development was planned but frequently the land remained vacant. Even during the time of demolition, some forward looking planners and real estate developers were recognizing the potential of the area for commercial and residential development. A series of one to three-story buildings were removed, closing down some long time business institutions. The effect was often worthwhile for the neighborhood. Directly between Harrison and Polk on Dearborn, the small fountain park that has become the center of Printers Row was created by the demolition of a line of small buildings.

The rail yard behind Dearborn Station was removed after passenger service was rerouted to Union Station. In 1976, ground was broken on Dearborn Park, the first new community to be built in the central city. Over a thousand units of low, mid, and high-rise apartments and townhouses would be built through the 1980s. The development included a beautiful small urban park which gives the area its name. This residential development gave impetus to development on Printers Row, which became a mecca for artists and others who wanted to both live and work in the large open spaces available in the old printing buildings.

The tension between development and preservation continues today as uses for desirable empty urban spaces are reconciled with historic and residential needs. Several open blocks on Dearborn Street are reminders of development plans announced with great flourish that were unable to overcome obstacles of financing or neighborhood opposition. The current building boom along South State Street, including large dormitory space for the downtown colleges, has demonstrated that effective use of urban planning can blend historic value with emerging needs.

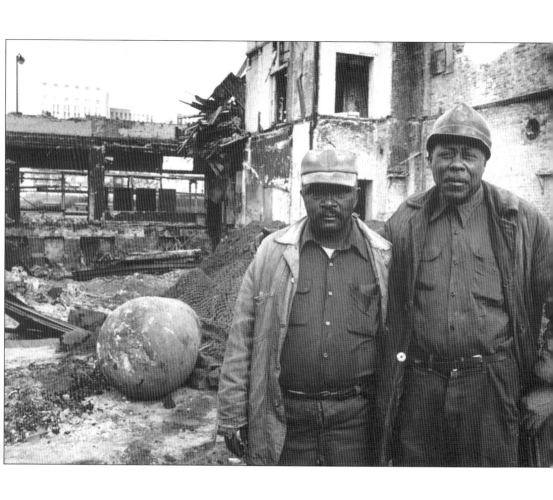

Opposite top: The remnants of Grand Central Station are pictured here. Of the six original train stations in Chicago, only Dearborn Station remains.

Opposite bottom: The interior of Dearborn Station shows why it was a candidate for destruction as well.

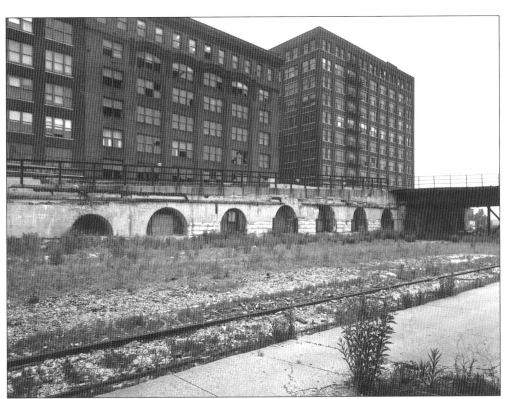

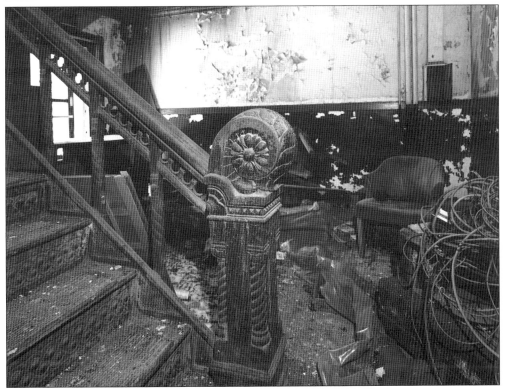

The Tru-Link Building on Harrison and Wells.

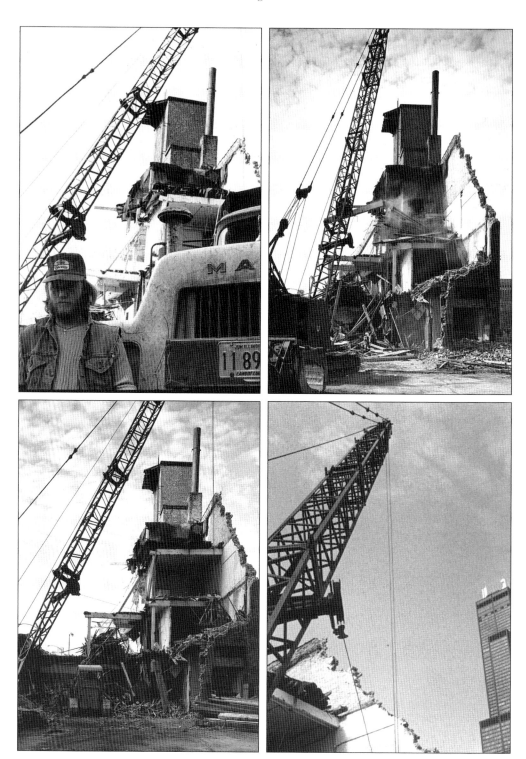

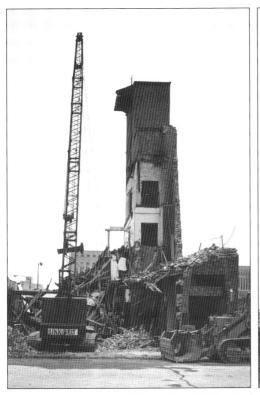

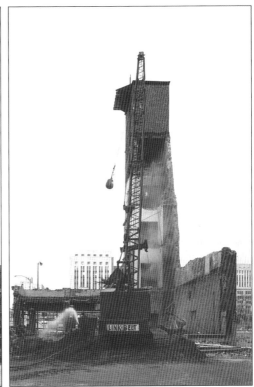

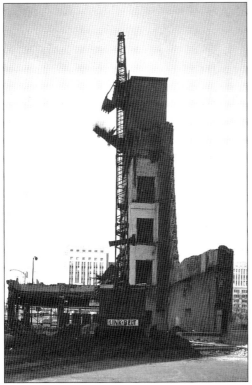

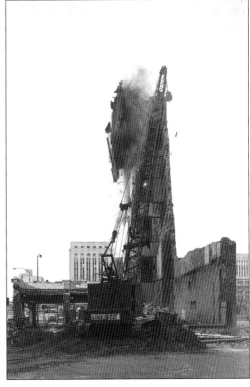

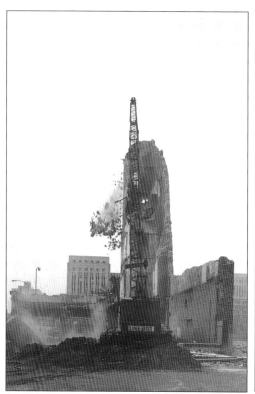
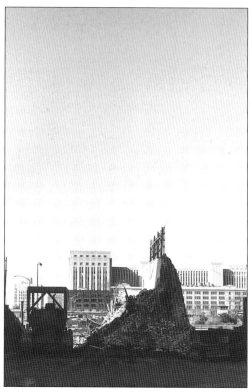
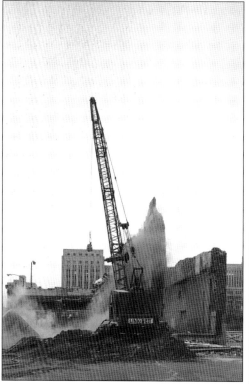
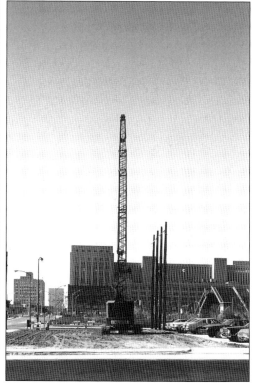

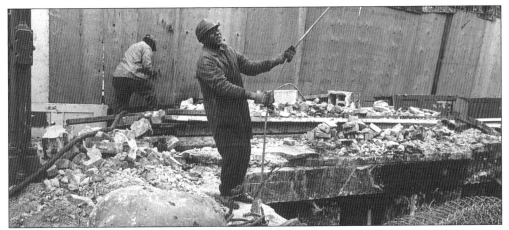

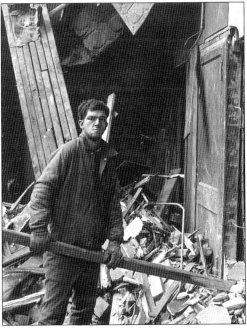

The C&A Tap and Reno's Restaurant were housed in two of the last buildings remaining from the 19th century. Three story buildings of this type once filled the streets of the Levee District. This site, at Dearborn and Polk, is now a vacant lot.

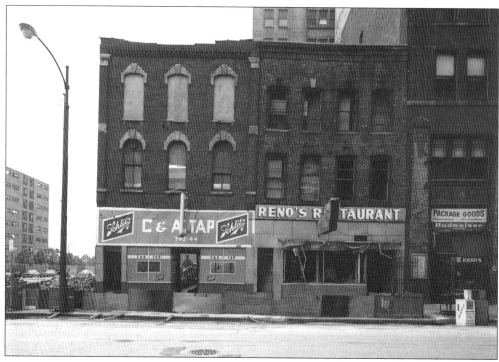

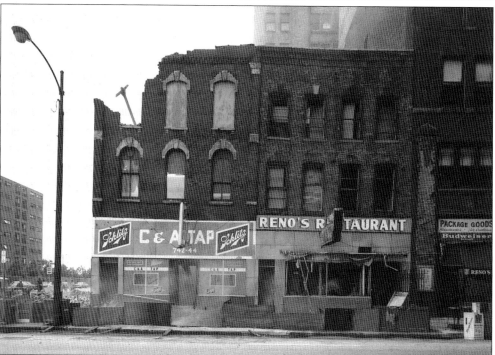

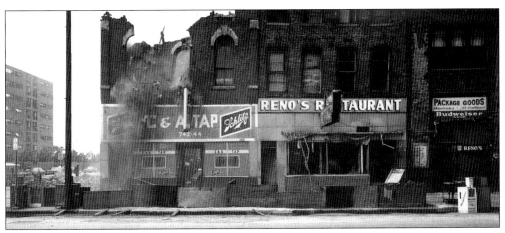

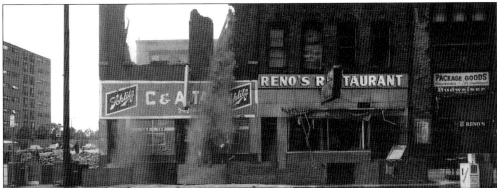

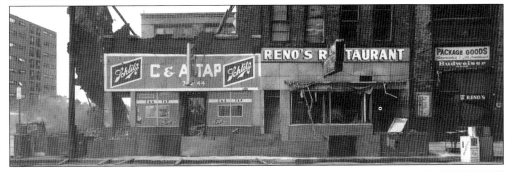

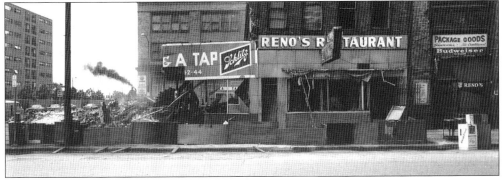

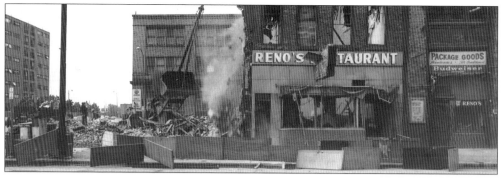

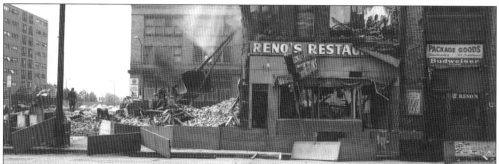

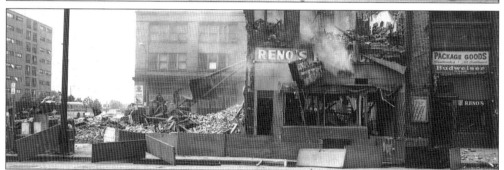

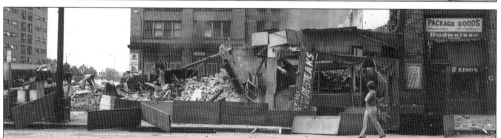

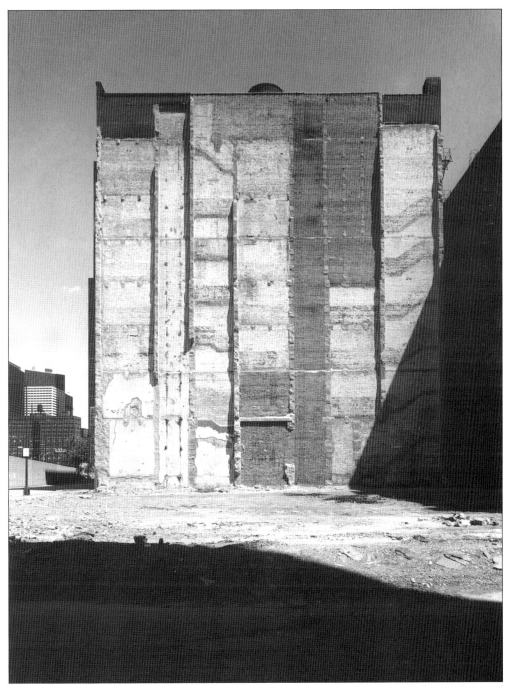

Some demolition cleared the way for new development. Much of it left empty lots and scarred buildings.

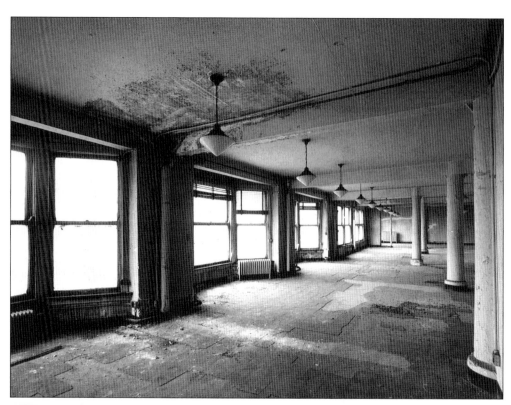

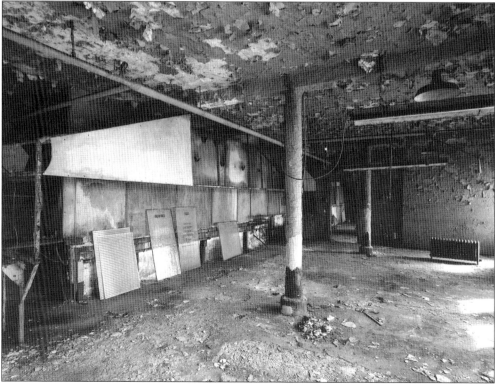

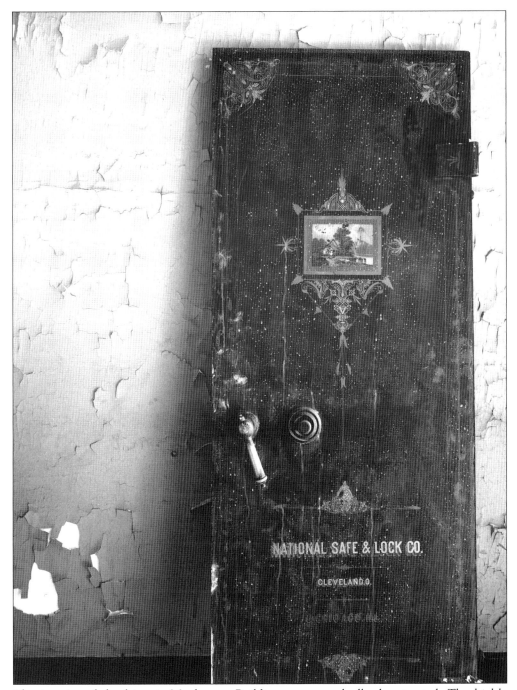

The interior of the historic Manhattan Building was once badly deteriorated. The highly detailed safe door stands unused.

Opposite: Buildings were left empty and became refuge for the homeless who frequently "squatted" in the unused spaces.

Some demolition led to useful open spaces. A lovely fountain park now stands where these two- and three-story buildings had been. The Borland Building sits in the background.

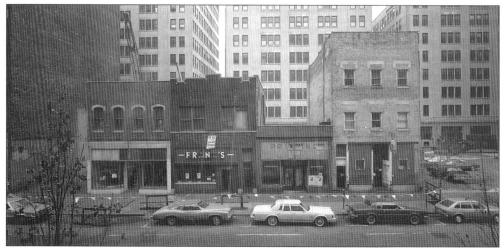

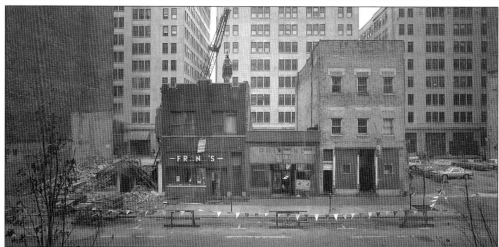

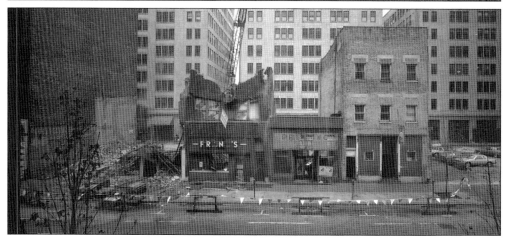

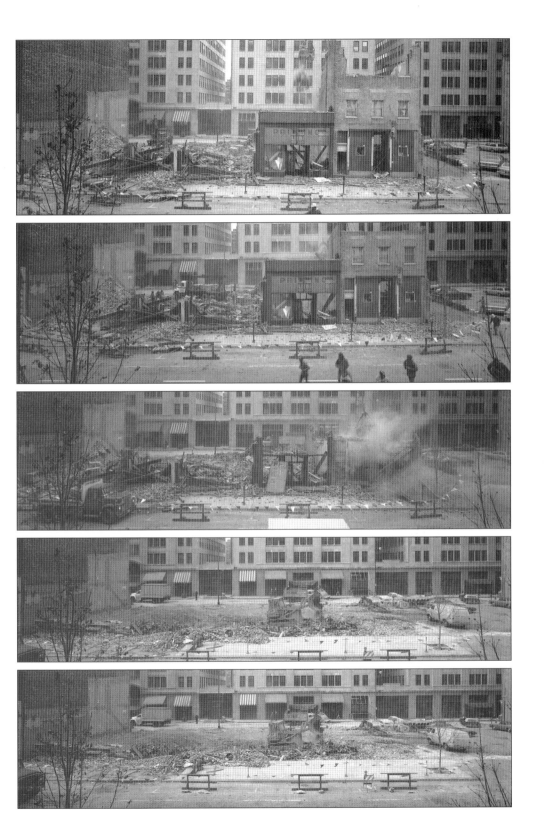

Seven

URBAN LANDSCAPES AND PIONEERS

Rebirth

WHILE THERE WERE economic and demographic forces that drove the revitalization of areas such as Printers Row in the 1980s, the success of the neighborhood renaissance was in many ways directly attributable to the foresight and vision of a set of developers and civic leaders. Harry Weese, John Baird, Larry Booth, Bette Cerf Hill, Theodore Gaines, Robert Wislow, and many others played a significant role in preserving the architectural treasures of Printers Row from the wrecking ball and revitalizing the neighborhood.

Early residents were frequently artists, architects, and photographers looking for large, well lit spaces to use as studios and residences. The characteristics of the buildings that made them fit for printers were especially attractive to these new dwellers. Large windows and open spaces fit the needs of these creative people. Across the country, the process known as gentrification had begun as old neighborhoods were converted into upscale housing. The northern neighborhoods of Chicago such as Old Town and Lincoln Park were full of existing residential units which easily became apartments and condominiums. The special character of the industrial buildings in Printers Row offered a different opportunity. The first industrial lofts were opened in the Donohue building and gave residents wide choices for open spaces with high ceilings and distinctive interior design. Residents found that the thick floors used to support heavy printing equipment made excellent soundproofing and could be attractively covered with hardwood floors. Frequently, very modern interiors were set into the old brick walls.

More recent renovations have been carried out by development companies which gut the entire building and create multiple units with the same floor plan and design. The earliest lofts in Printers Row were often developed one at a time to fit the needs and specifications of the new resident. This has contributed to the striking individuality of many of the units. Some of the earliest residents of the lofts in Printers Row still live in the neighborhood and enjoy telling about the development period when gentrification co-existed with homeless squatters who still occupied other parts of the building.

By the 1990s, the building and conversion momentum had grown and the area was primed for the decade long boom. Scattered lofts and apartments were quickly surrounded by occupied buildings as thousands of people recognized the opportunities offered by the convenient South Loop location. Several attempts were made to build new high-rise apartments in the middle of Printers Row. By this time, an active neighborhood organization had formed to guard the special character and flavor of the area. Any new development would have to be in harmony with the history and architecture of Printers Row.

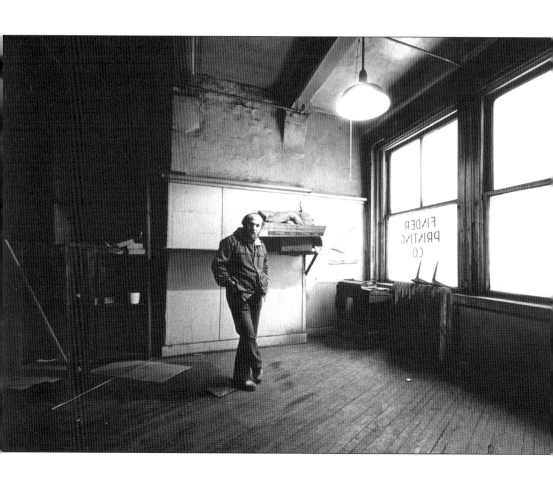

Renovators faced a grim task in bringing new life to the abandoned buildings of Printers Row.

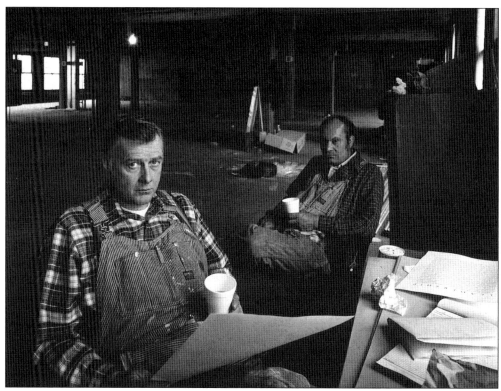

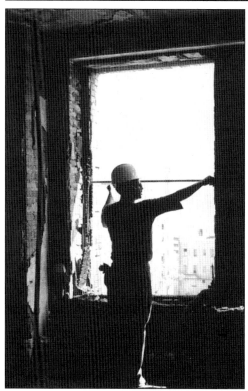

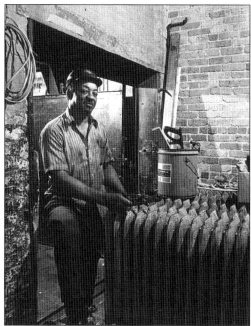

By 1980, the first lofts in Chicago were being built in the Donohue and Rowe Buildings. It would mark the beginning of the neighborhood's transformation.

Tyner White occupied an unused place in the Donohue Building. As the buildings were purchased and renovated, the squatters were displaced and new residences filled the buildings. This space became the residence of architect Scott Sonic.

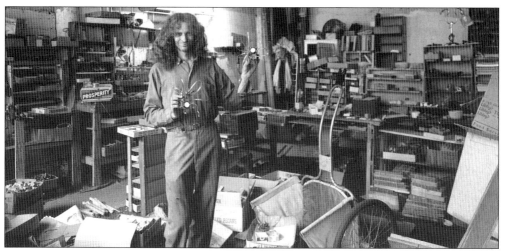

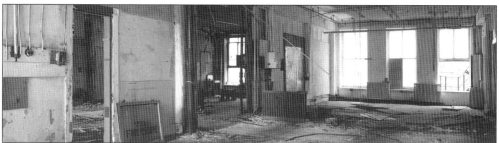

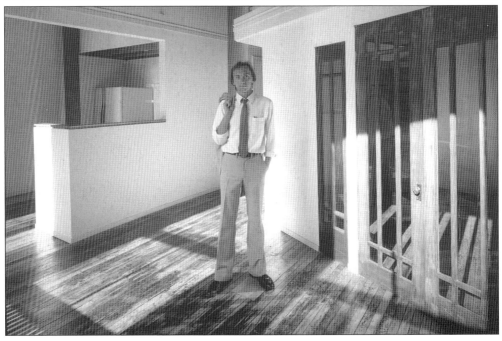

Artists and photographers were among the first residents of the area, building studio space and residences. The group includes Phil Kupritz and his family; Bill Cagney and Robert Vogel; Michael Mauney; and Richie Victor. These artistic roots have given Printers Row a distinctive character.

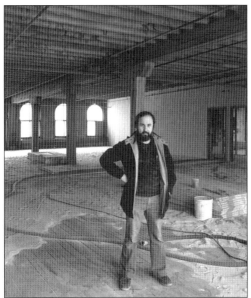 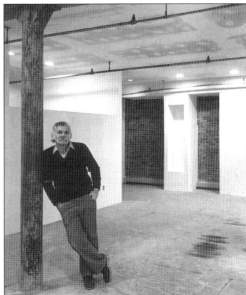

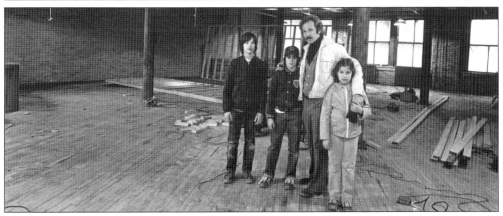

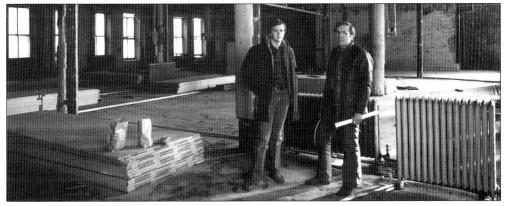

A bindery space becomes a darkroom for co-author Ron Gordon. The space was designed by Ron's brother Robert and built by Klindt Houlberg and Peter Newman.

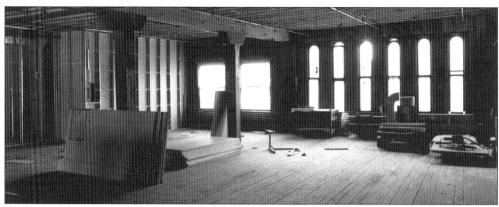

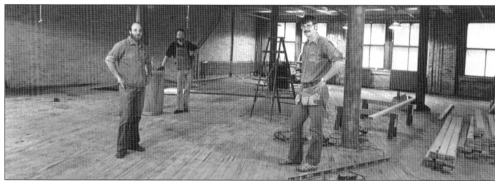

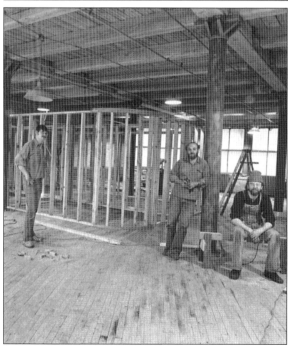

Gradually, couples and families began to develop living spaces in the old printing buildings, attracted by the open bright spaces. These include the Calvert and the McDowell residences.

The distinctive arch at the center of the Donohue Building was blocked up. This is seen from the interior of Bill Cagney's loft. Reopening the arch created an attractive window in a new loft space.

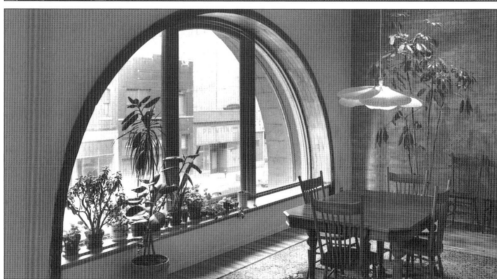

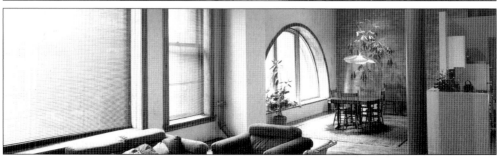

Bright open interior design including hardwood floors and creative use of columns became the signature of Printers Row lofts. These were the lofts of Jessica Swift, George Hinds, Bill McDowell, and the Historic Resources Office.

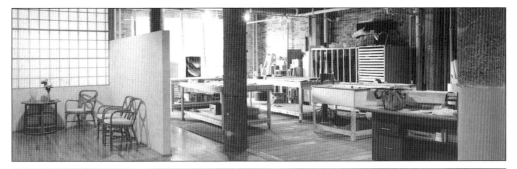

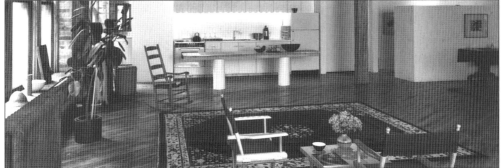

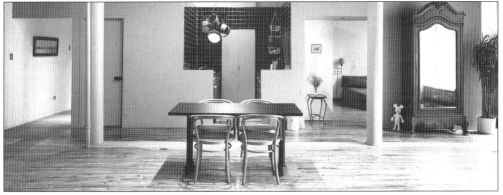

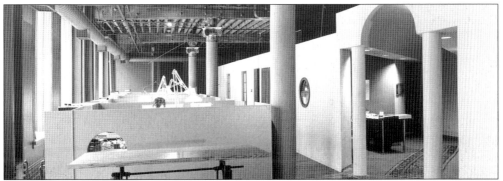

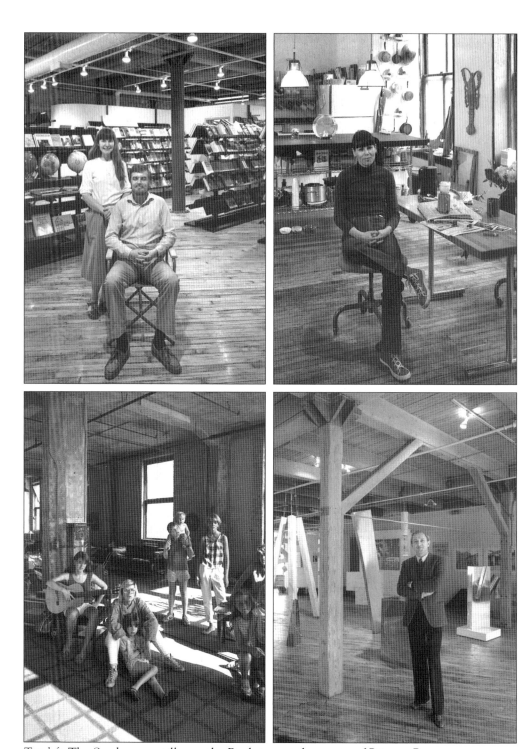

Top left: The Sandmeyers still own the Bookstore at the center of Printers Row.
Top right: Artist Lois Grimm created a comfortable kitchen space.
Bottom left: The young Anderson family used the open space for music and play.
Bottom right: Virginio Ferrari employed open spaces for exhibition of modern art.

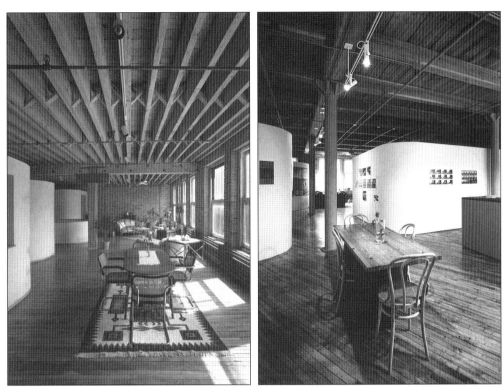

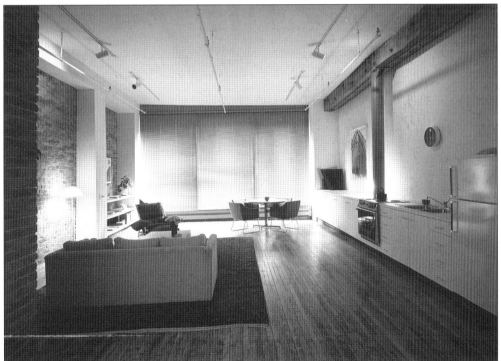

The casual elegance of Printers Row lofts made them attractive to a wave of people returning to city living.

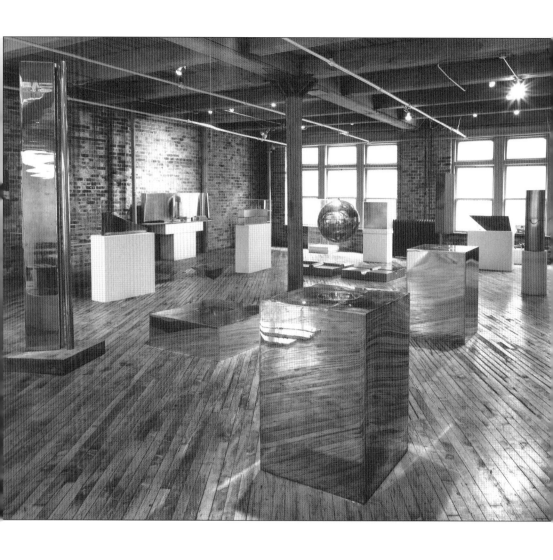

Eight
BOOKS AND ART
Vitality

TODAY, PRINTERS ROW is a thriving commercial, residential, and artistic area. It has always maintained a sense of its roots in the printing industry by paying special attention to books and literature. At the north end of the neighborhood is the monumental Harold Washington Library, the main branch of the Chicago Public Library System. The building named after the man dubbed "the people's mayor" is appropriately enough "the people's library." The city invited architectural firms to submit designs, which were displayed in the Chicago Cultural Center for several months in 1989. Thousands of citizens inspected the competing proposals and voted for their choice. Robustly traditional, with details derived from many classic Chicago forms, this 1991 Hammond Beeby & Babka building was the winner. Visitors especially enjoy the whimsical copper roof with details that include the very studious looking owls.

The first weekend in June is devoted to the neighborhood's largest occasion, the Printers Row Book Fair, now sponsored by the *Chicago Tribune*. The fair attracts over 75,000 people to a wide variety of readings, author lectures, book signings, and exhibits. In a festive atmosphere, the tradition of books that is at the heart of Printers Row is celebrated in one of Chicago's popular summer festivals.

Throughout the years, artistic events such as Sculpture Chicago and Judy Chicago's Dinner Party have drawn visitors to the area. Many artists still keep their studios in the area and art students can frequently be seen sketching in the attractive fountain park. Gourmand's Coffee Shop exhibits art work from a variety of local artists on a rotating basis.

Out of town visitors frequently enjoy the world class service of Hyatt in the unusual boutique hotel setting of the Hyatt Printers Row located in the Morton Building. Convenient to business in the Loop, it also provides an interesting starting point for nightlife and entertainment. Visitors and residents enjoy food and beverages at such local establishments as Printers Row Restaurant, Prairie, Eduardo's Pizza, Trattoria Caterina, SRO, Gourmand's, Kasey's Tavern, Hackney's, Blackie's, and Bar Louie. During the summer months, all of the restaurants open sidewalk cafes which give the area an almost European flavor. It is not uncommon to see neighborhood dwellers sitting out in front of one of the restaurants chatting with passersby who are off on a stroll with their dogs.

Sandmeyer's Bookstore remains the center of the neighborhood. An early resident of the Rowe Building, it still offers the special charm and love of books that can be found in an independent bookseller.

Attractive apartments in the Printers Square (Borland) Building and condominiums in the Donohue, Franklin, Peterson, Terminals, Transportation, and other buildings anchor the neighborhood and make Printers Row seem like a small town set in the middle of one of the world's great cities.

Harry Weese, Ken Schroeder, Virginio Ferrari, George Hinds, and Ron Gordon were among the early visionaries bringing life back to Printers Row.

Opposite top: Civic leaders and members of the artistic community joined to plan events such as Sculpture Chicago.

Opposite middle: Mayor Harold Washington provided support for the efforts of Printers Row developers and planners.

Opposite bottom: Sculpture Chicago helped bring crowds back to the streets of Printers Row in the early 1980s.

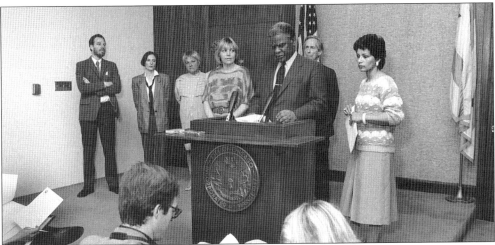

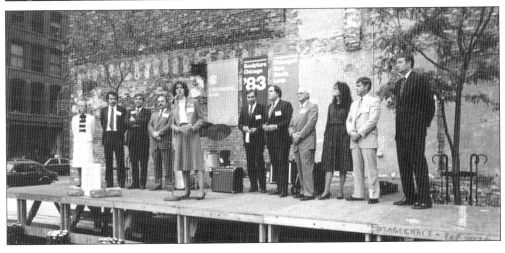

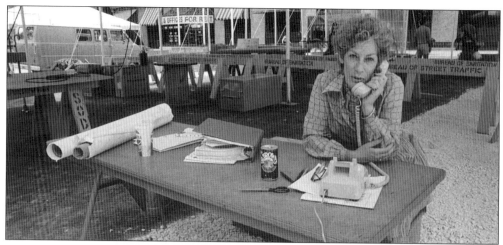

Opposite top: : Bette Cerf Hill works the phones in planning for Sculpture Chicago.
Opposite middle: : Carolann Haggard was director of Sculpture Chicago.
Opposite bottom: : Marcia Weese was an artist in the exhibit.

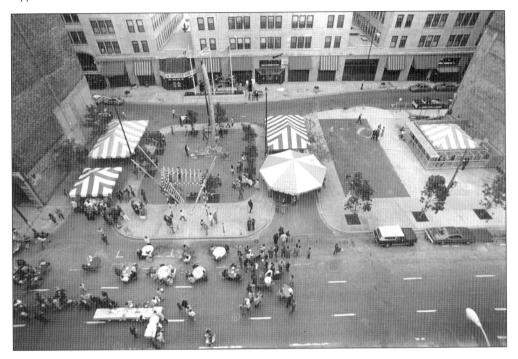

Sculpture Chicago brought crowds back to Printers Row. The fountain had not yet been added to the small plaza.

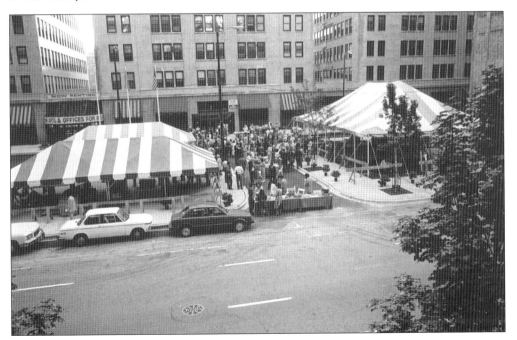

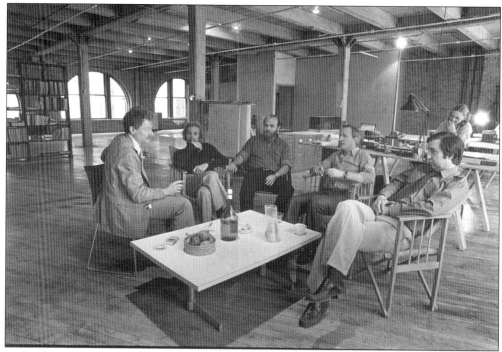

In the Rowe Building, architects and building owners plan for the future of the area.

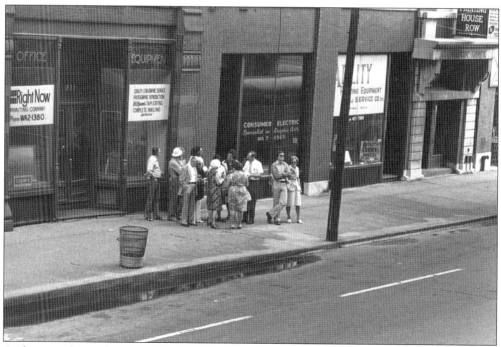

Architectural tours began to expose Chicagoans to the treasures of Printers Row,

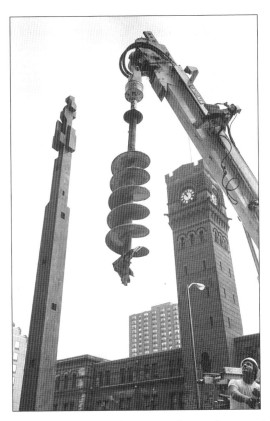

Dramatic sculpture filled the streets during the art exhibit.

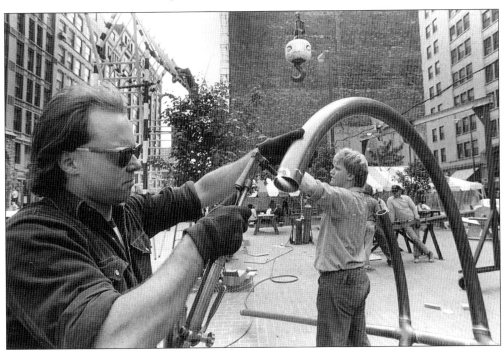

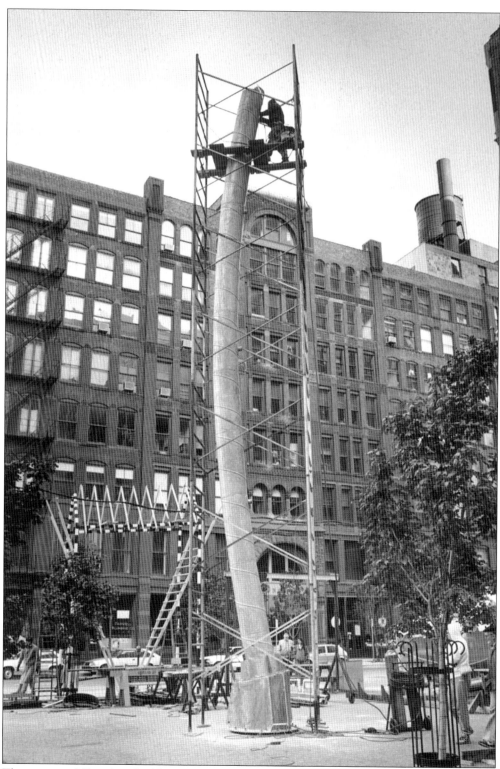

The renovated Donohue Building sits behind the modern sculpture.

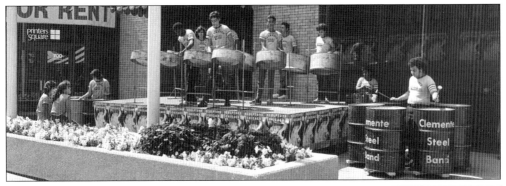

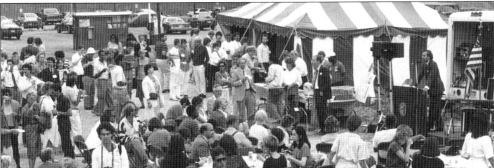

Music and crowds filled the streets during festival time.

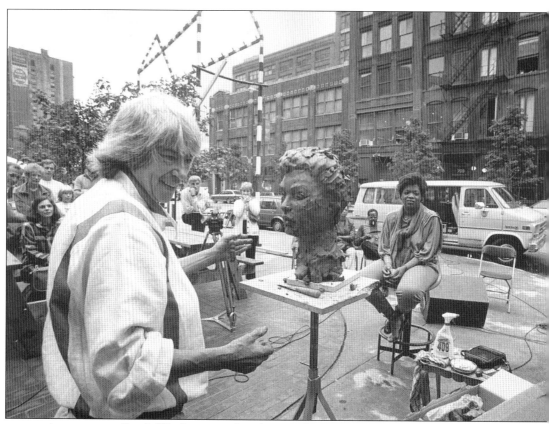

A very young Oprah Winfrey poses for a bust in the middle of Printers Row.

The Harold Washington Library rises at the north end of Printers Row.

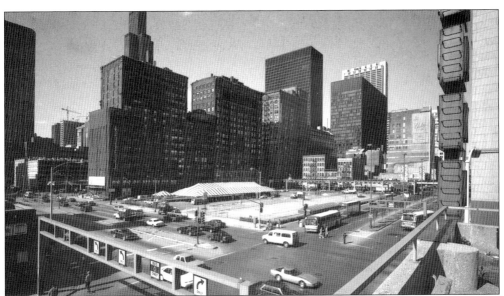

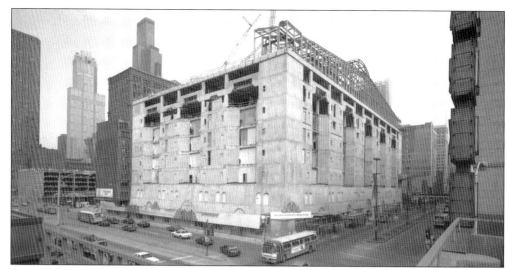

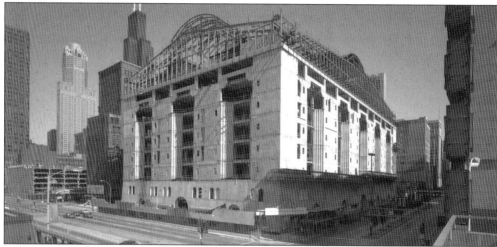

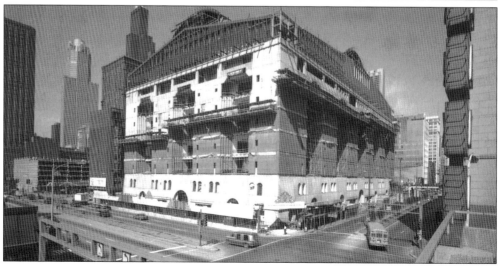

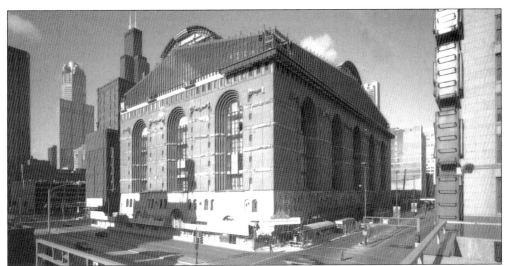

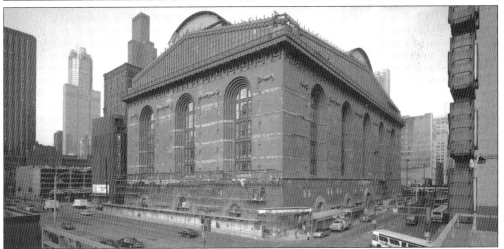

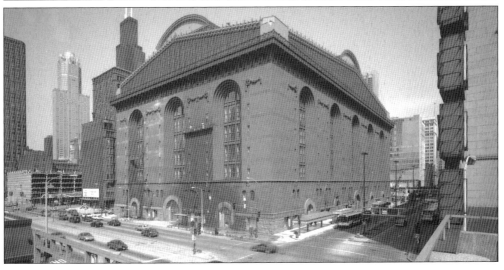

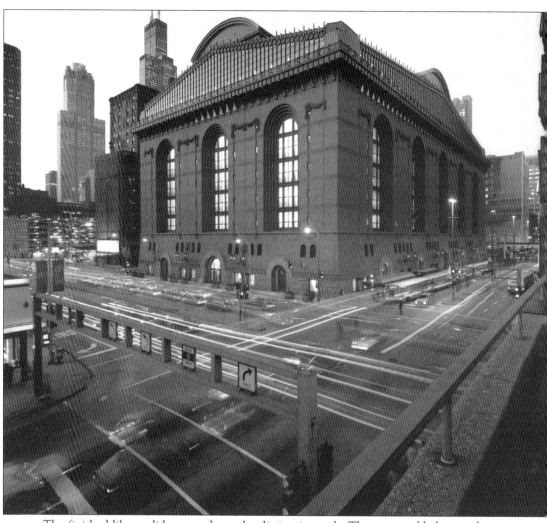

The finished library did not yet have the distinctive owls. They were added a year later.

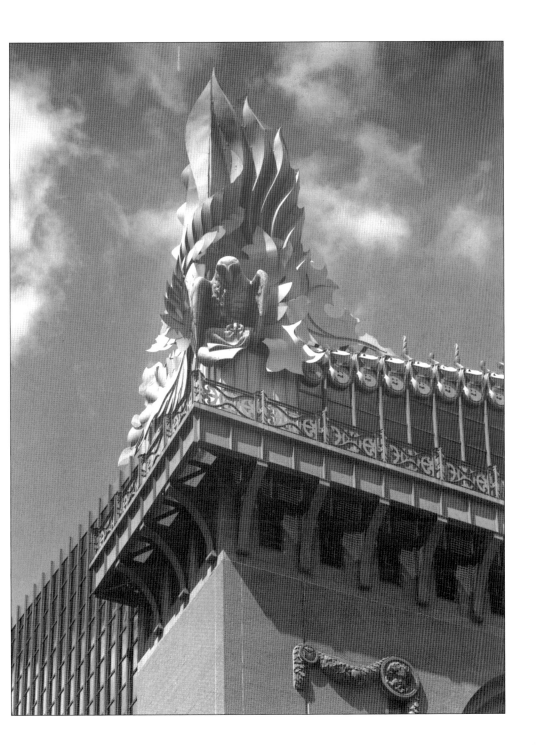

Where Conley's Patch had once been, River City emerged.

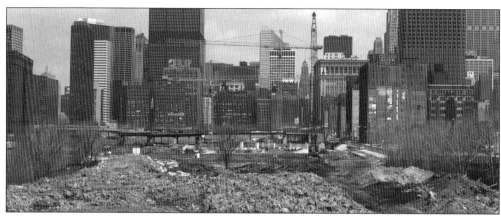

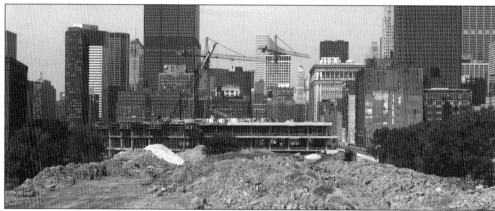

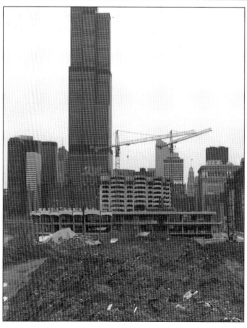

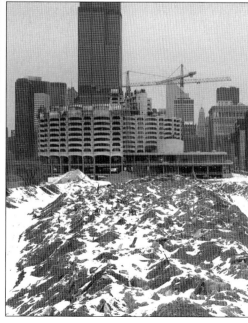

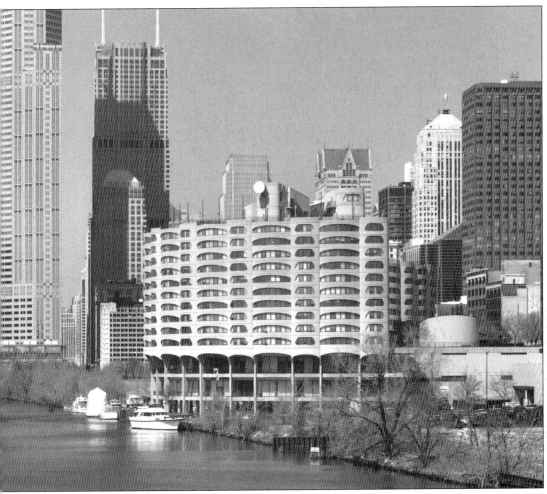

One of Chicago's most distinctive buildings, River City includes its own one acre park.

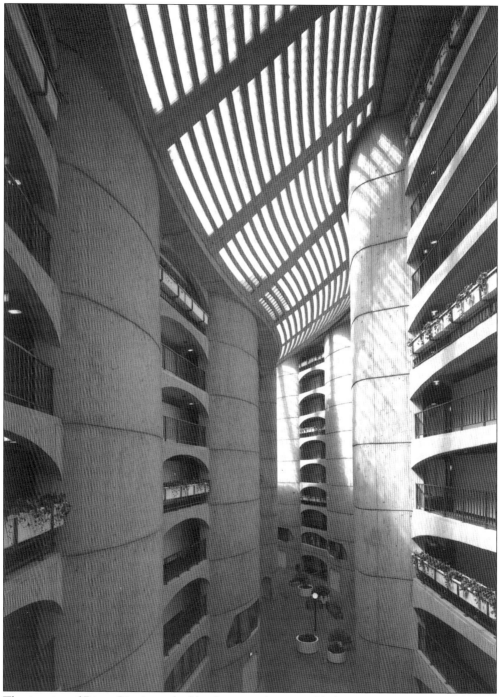

The interior of River City is marked by dramatic shapes and lighting.

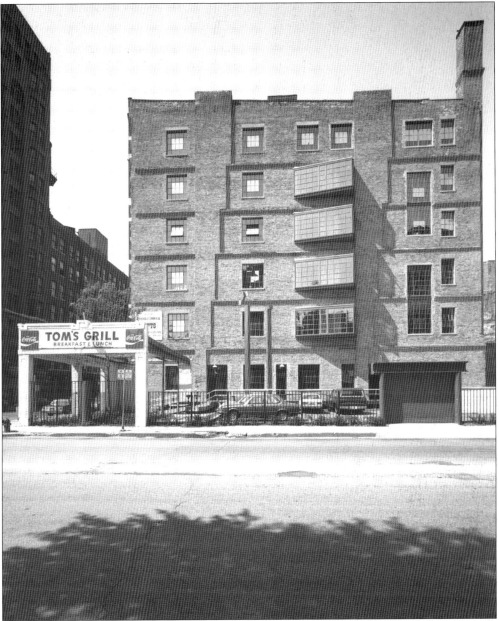

The side of the Mergenthaler, including the archeological remnant of Tom's Grill, demonstrates the contrast of the old and the new in Printers Row.

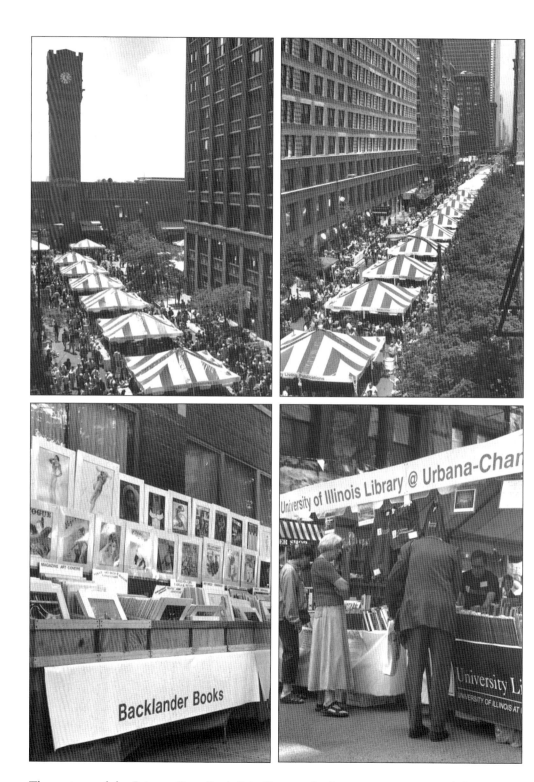

These views of the Printers Row Book Fair illustrate both its great expanse and the sense of community generated by a love of books.

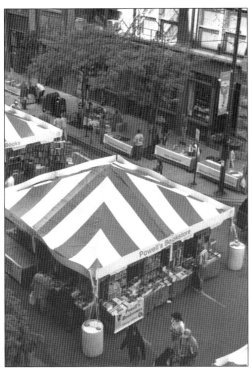

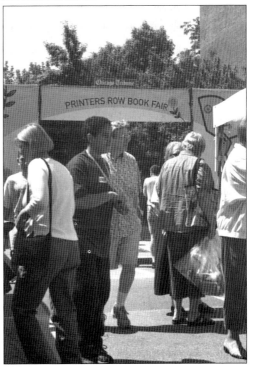

ACKNOWLEDGMENTS

THE AUTHORS would like to gratefully acknowledge the assistance of Chris Ferrari for darkroom work and help in the field; Sandy Steinbrecher for darkroom work and proof reading, Emma Rodewald for help in organizing the photo archive; Bonnie Sanchez Carlson from the South Loop Planning Board for background and archival photographs; Bette Cerf Hill for background information; Sheila Malloy for direction to the right people; Sallie Gordon for her love and constant support; and Sandmeyer's Bookstore, where the idea for the book began.

PICTURE CREDITS

All photographs are by Ron Gordon except:
- Book Fair and Hyatt photos by Chris Ferrari
- Picture of Ron Gordon at the beginning of Chapter 7 is by Michael Mauney
- Archival pictures in Chapter 1 courtesy of Chicago Public Library archives

AUTHOR BIOGRAPHIES

RON GORDON is a professional photographer and professor of architectural photography. His work is included in a number of publications and permanent exhibitions including the Art Institute of Chicago. His studio has also worked on the photographic portions of such films as *The Fugitive* and *A River Runs Through It*. His work can be seen at http://www.rongordonphoto.net

JOHN PAULETT is the author of *Pentecost, Peanuts, Popcorn and Prayer* and several plays including *In the Case of Henry Tandy* and *If You Miss the Train I'm On*. He played with the bluegrass group *Home Brew* and can be heard on their CD *Quilting Music*. John can be contacted at jpaulett@sbcglobal.net.